PENCIL SKETCHING

THOMAS C. WANG

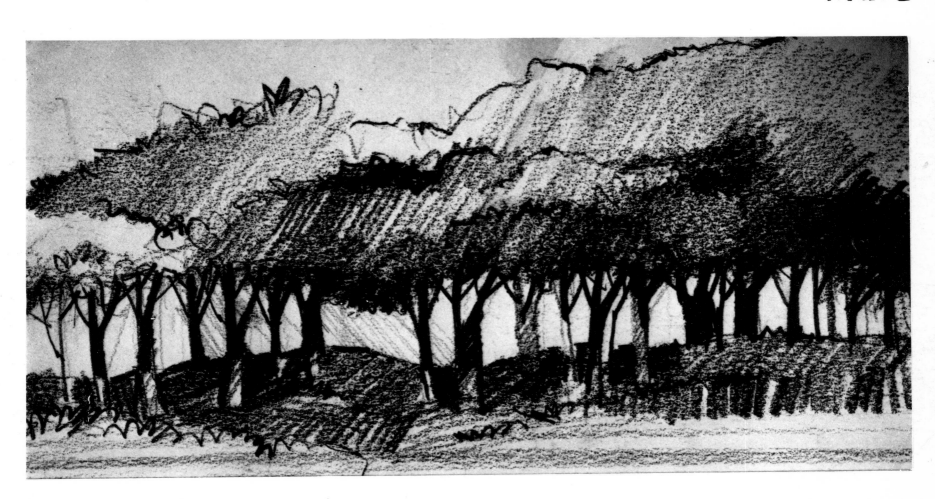

to my parents......

Designed by Thomas C. Wang

Published in 1977 by Van Nostrand Reinhold Company Inc.
135 West 50th Street, New York, N.Y. 10020 U.S.A.

Van Nostrand Reinhold Australia Pty. Limited
480 Latrobe street, Melbourne, Victoria 3000, Australia

Van Nostrand Reinhold Company Limited
Molly Millars Lane, Wokingham, Berkshire, RG11 2PY, England

16 15 14 13 12 11

Library of Congress Cataloging in Publication
data
Wang, Thomas C.
 Pencil sketching

 Bibliography : P
 Includes index
 1. Pencil drawing. I. title
NC 890. W25 741.214 77-1095
ISBN 0-442-29177-9

TABLE OF CONTENTS

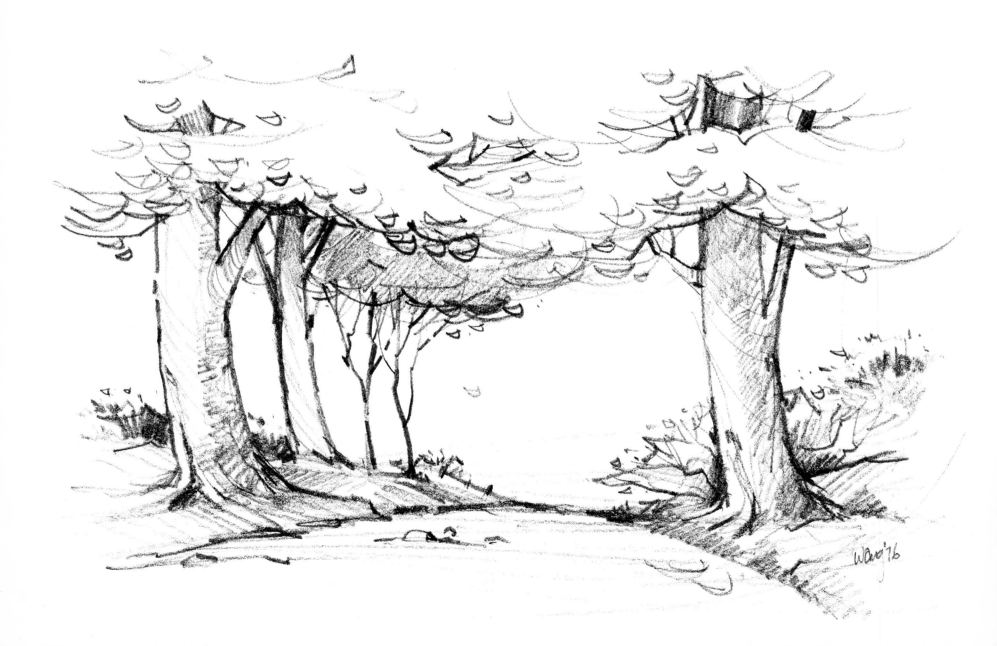

Wang'76

In this book, my main concern has been to present the fundamental principles of pencil sketching as simply as possible so that the layman and student can learn to sketch and draw with pencil.

Pencil is often seen as a cheap graphic medium. To a lot of students, pencil sketching is less interesting to learn because of its messiness and the lack of colors. It is true that pencil has its faults and limitations, yet it is still the most widely used tool for artists today.

Pencil is also inexpensive in terms of the paper and other materials that are required. These materials are easy to carry and there is no lengthy or difficult preparation involved. The pencil medium is highly flexible, and it is responsive to any variation of pressure or direction applied to it. this allows the artist to produce various kinds of strokes as well as a wide spectrum of tone, ranging from light gray to intense black; this could all be done with one simple sketching pencil. Unlike other media that require time to dry, sketching with pencil is far less time-consuming. The pencil can be used independently as a finishing medium, and it can also be combined with many other media as outline or touch-up.

Very often the pencil is the easiest medium to get used to, due to our familiarity with it in daily use, as in writing. This kind of familiarity is very helpful in teaching pencil – sketching techniques because the students are free to concentrate on other problems which make learning to sketch easier. I also find pencil sketching the most appropriate medium for expressing the many characteristics of natural environments. The expression of natural form and texture with pencil can be made rich and complex in ways that neither pen nor color markers can achieve.

It is my hope that this book will not only express the amazing potential of the pencil but also will increase the student's ability to sketch rapidly and confidently with pencil.

Thomas Chi-chung Wang

Dec. 1976, Urbana, Illinois.

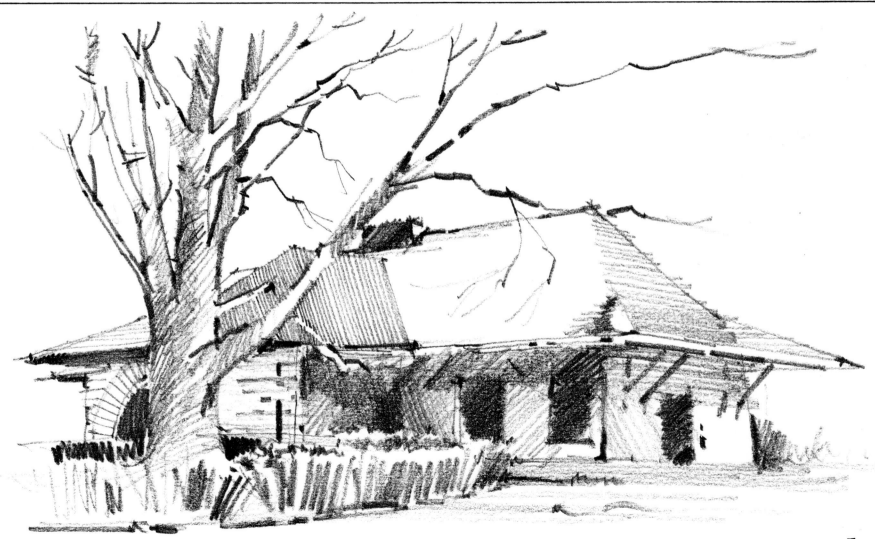

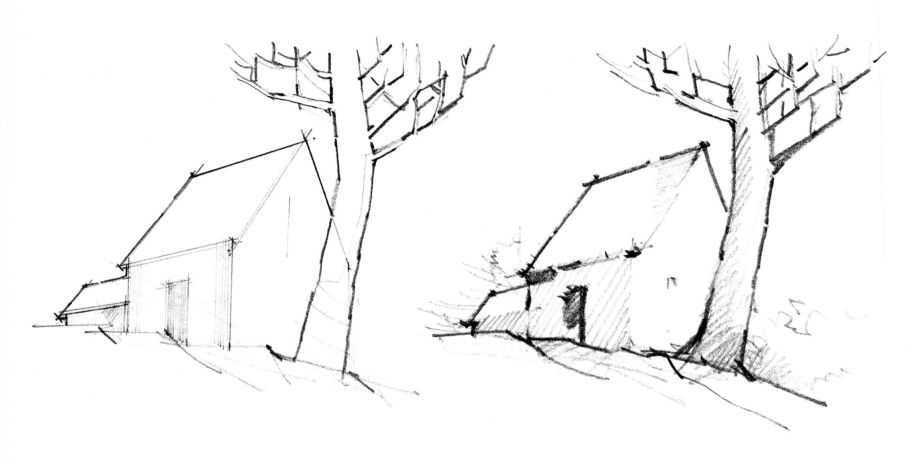

OUTLINE DRAWING (layout)

Building form mechanical;
simple; no detail;
unfinished.

QUICK SKETCH

use only a few lines to
express the image;
a finished sketch by itself.

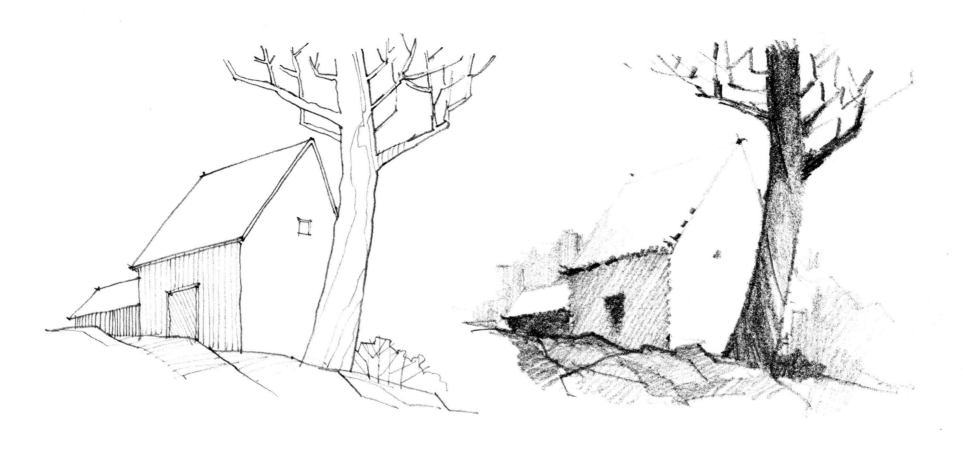

LINE DRAWING

Line width similar ;
no variations ;
shows details.

SHADING

Use a variety of tones
to express different
levels of planes.

9

TYPES OF PENCIL SKETCHING

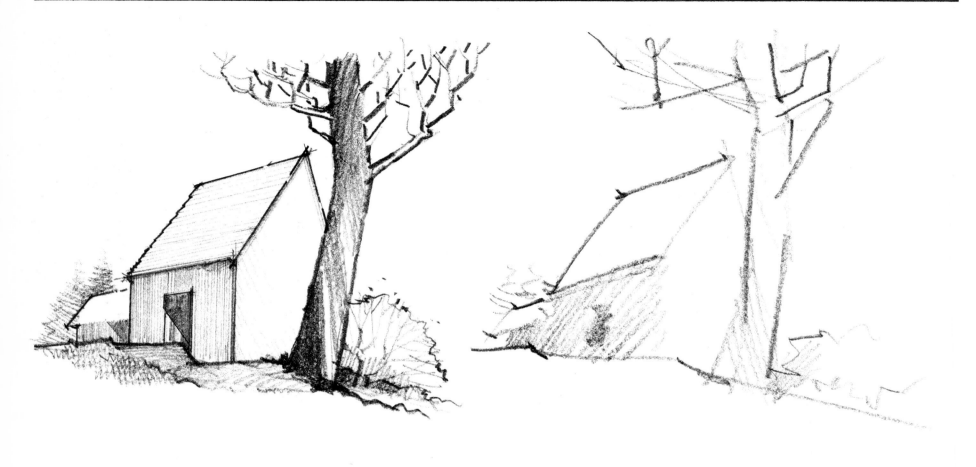

FINISHED RENDERING

Carefully detailed;
well proportioned;
accurate perspective.

IMAGE STUDY

sketchy ; quick ;
lacks details

EQUIPMENT

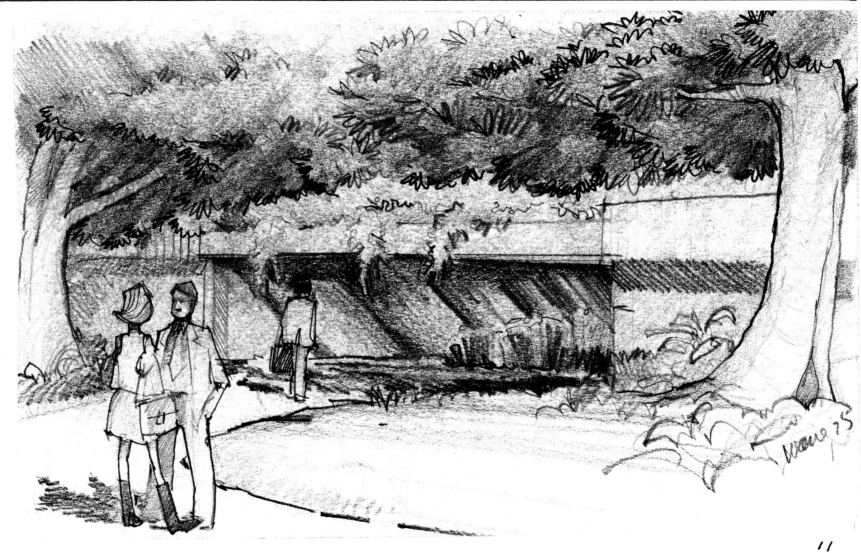

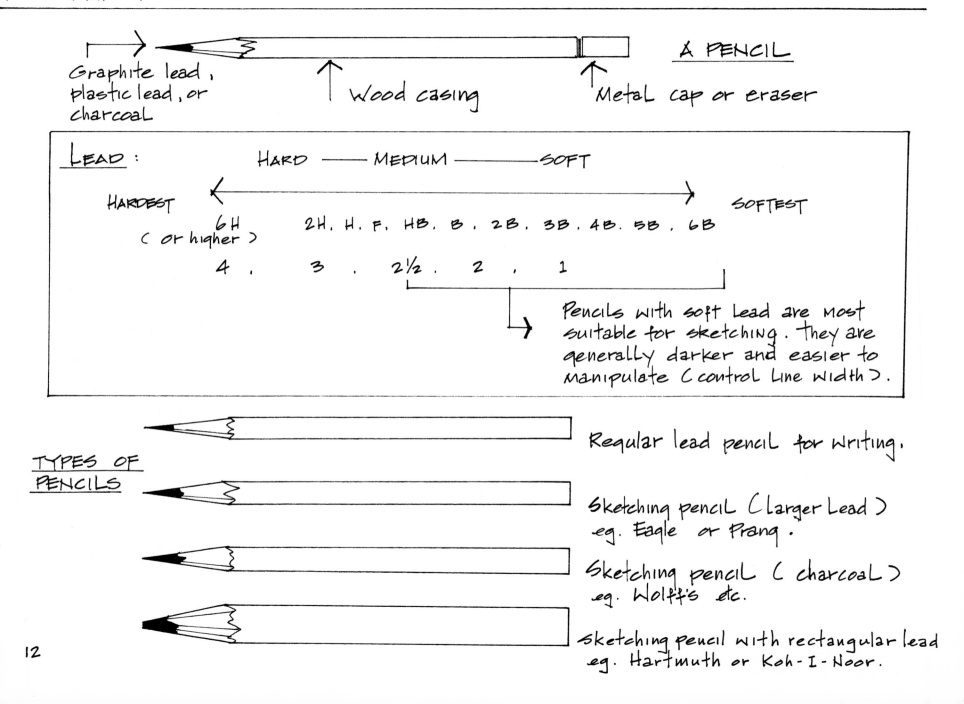

A PENCIL

Graphite lead, plastic lead, or charcoal

Wood casing

Metal cap or eraser

Lead:

HARD ——— MEDIUM ——— SOFT

HARDEST ←————————————————→ SOFTEST

6 H (or higher)

2H. H. F. HB. B. 2B. 3B. 4B. 5B. 6B

4 . 3 . 2½. 2 . 1

Pencils with soft lead are most suitable for sketching. They are generally darker and easier to manipulate (control line width).

TYPES OF PENCILS

Regular lead pencil for writing.

Sketching pencil (larger lead) eg. Eagle or Prang.

Sketching pencil (charcoal) eg. Wolff's etc.

Sketching pencil with rectangular lead eg. Hartmuth or Koh-I-Noor.

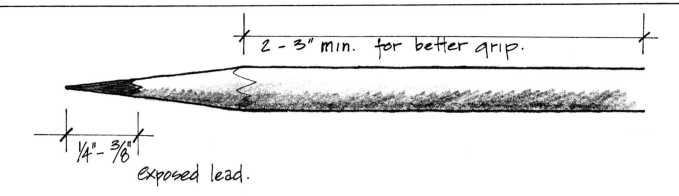

2 - 3" min. for better grip.

1/4" - 3/8"

exposed lead.

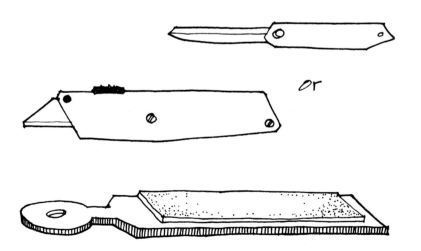

or

Sharpen your pencil with a pencil sharpener or a small pocket knife.

Use long exposed side of the lead for better shading. Use sides of the exposed lead for broad strokes.

Avoid pointed or conical tip except in drawing details. A sharp lead point will scratch the paper and hinder movement.

Rotate the pencil to maintain a consistent lead point.

Use a sanding block for fine sharpening.

 # PAPERS

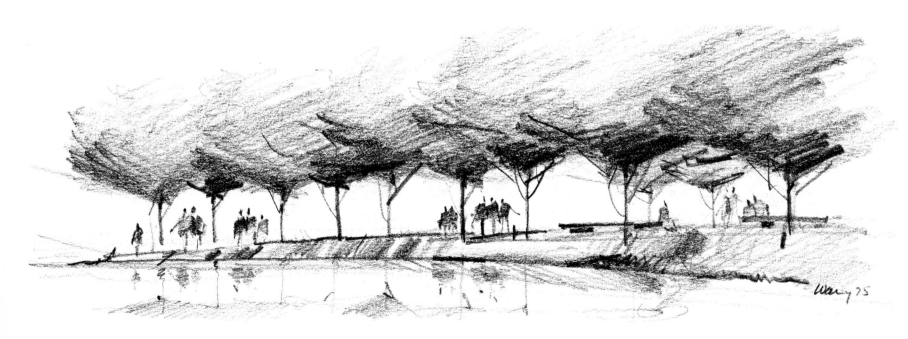

Generally, softer pencils are recommended for smooth papers and harder pencils for coarser or rough papers.

Coarse papers tend to wear out the points of pencils. Therefore, they are more difficult to use in sketching because of the accumulation of fine graphite particles.

Rough papers are not reccommended for small-scale drawings because the texture cannot reveal the fine details.

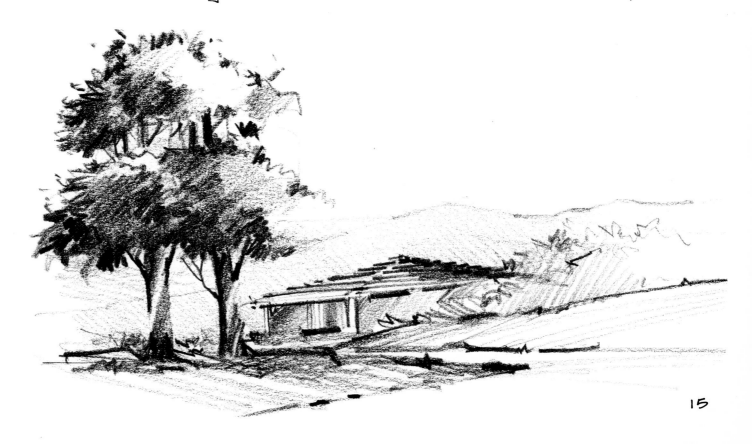

PAPERS

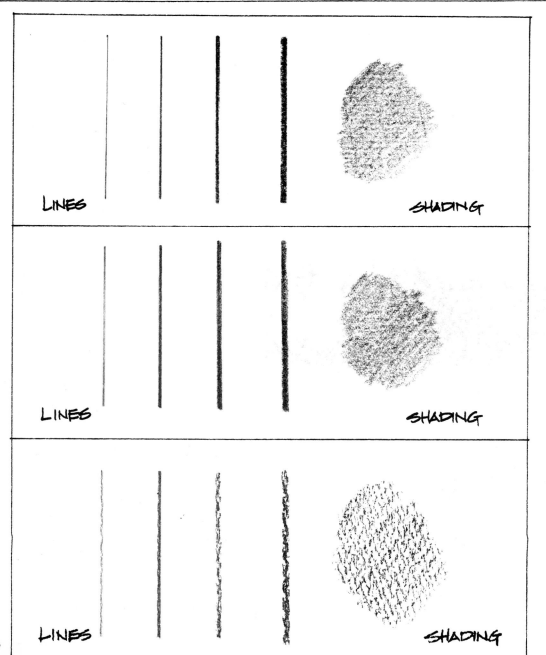

LINES SHADING

LINES SHADING

LINES SHADING

EXAMPLE : 1 Regular bonded paper.

Excellent line quality. and even shading.

EXAMPLE : 2 Strathmore Alexis Drawing 400-3.

Excellent line quality but shading slightly grainy.

EXAMPLE : 3 Strathmore Watercolor 400 series.

A unique paper for sketching; texture coarse and grainy; lines lack crispiness & sharpness.

EXAMPLE A: on Strathmore Alexis
drawing 400-3

A high=quality paper for
pencil sketching. Its
surface is smooth yet
non oily.

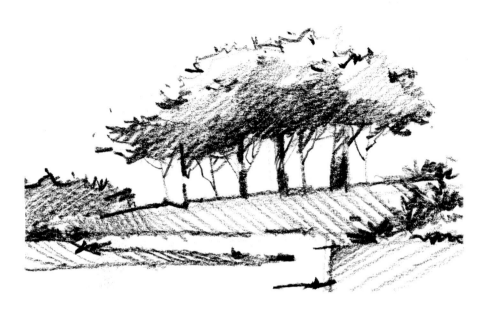

EXAMPLE B: on Strathmore Water-
color Paper 400 Series

A thick & coarse paper
primarily for watercolor.
It is best suited for
large-format drawings
in pencil sketching. It is
not suitable for details and
outline.
Not recommended for
beginners!

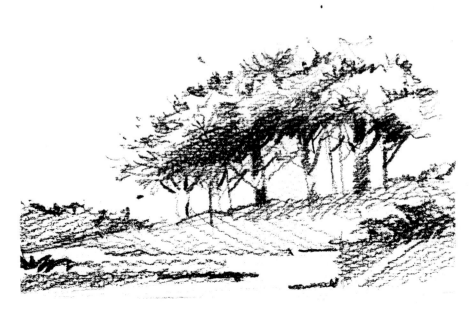

17

 # TECHNIQUES

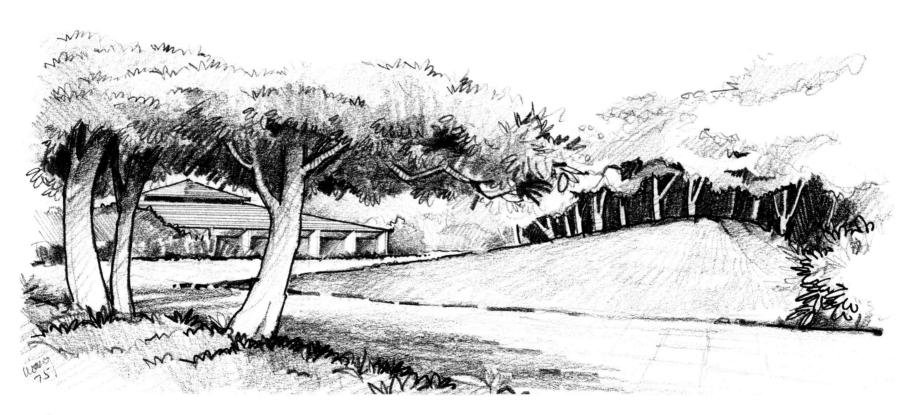

INCORRECT: WRITING FORM

CORRECT: SKETCHING FORM

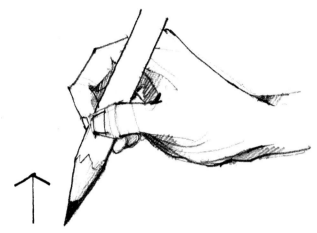

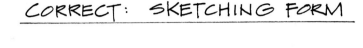

OR

Minimum wrist motion; mostly finger movement. It is less flexible because the grip is too tight. This form is not recommended for sketching except for detailing.

Maximum wrist motion; larger arc; covers more area.
Loose grip for better line control; it is easier to manipulate the pencil.

A LINE begin end

eq. A —————————————— 2-dimensional ; no life ; flat.

eq. B 〜〜〜〜〜〜 Line begins to communicate volume and suggest Movement.

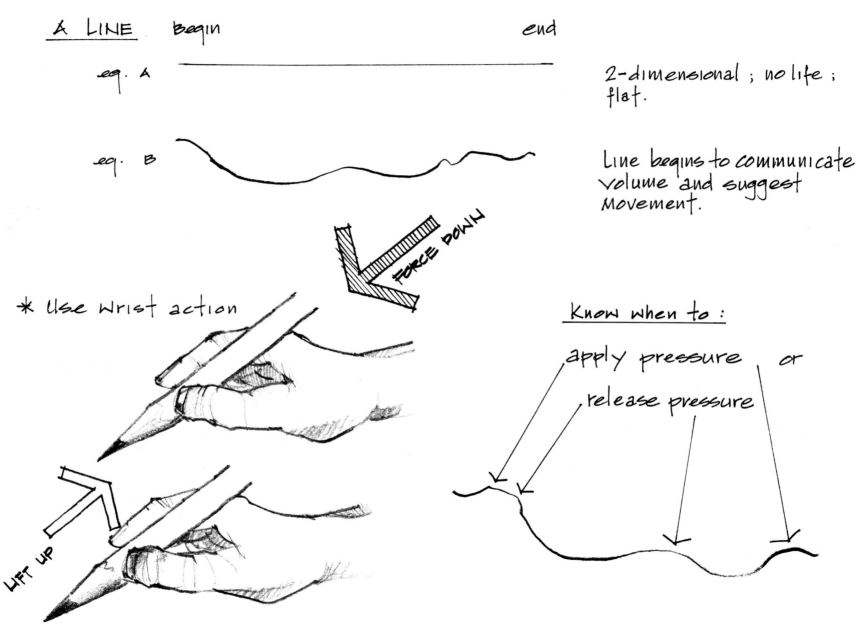

FORCE DOWN

* Use Wrist action

LIFT UP

Know when to :

apply pressure or

release pressure

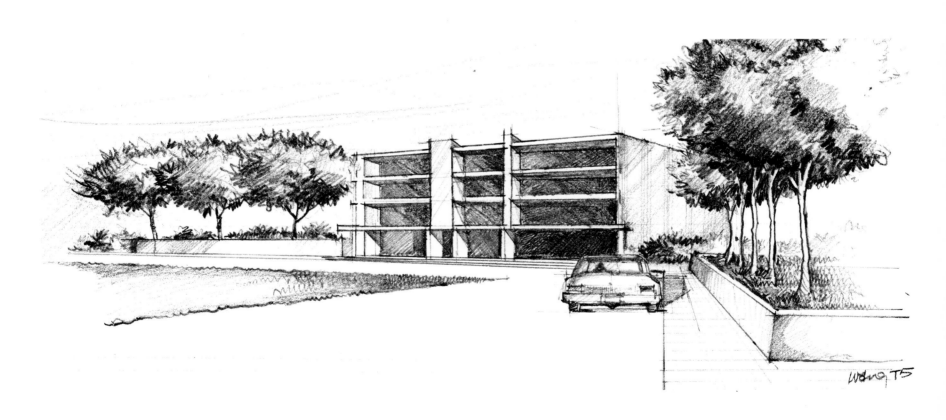

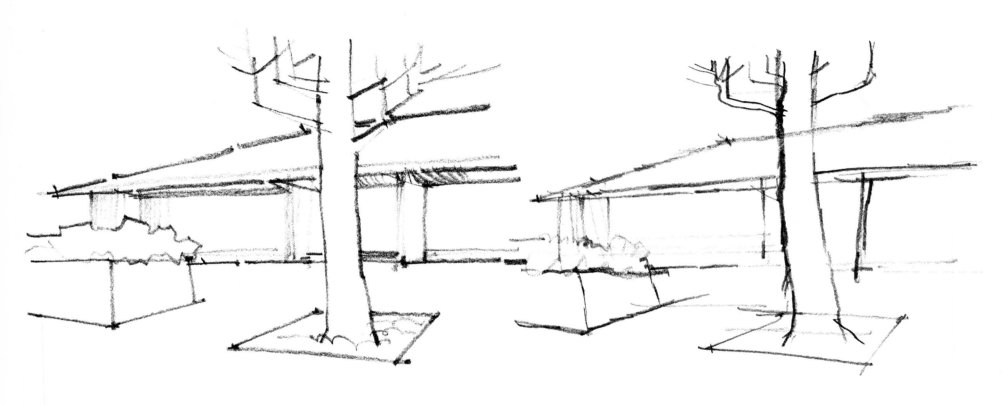

DIRECT LINE

Consistent line weight
shows confidence and
the use of arm or wrist
motion.

SKETCHY LINE

Inconsistent line weight indicates
a lack of confidence: afraid to
make mistakes and uses too
many short strokes (a result
of finger movements).

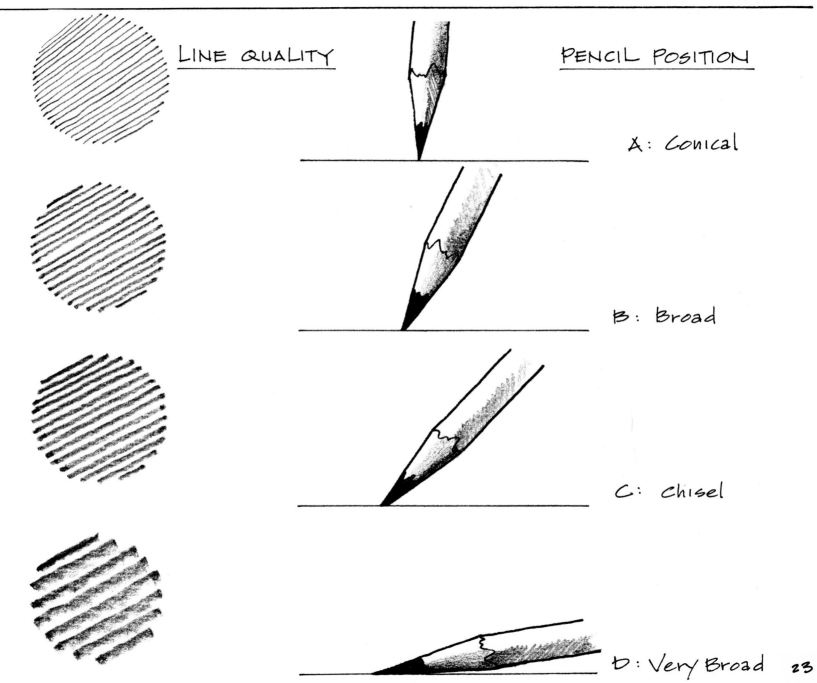

LINE QUALITY

PENCIL POSITION

A: Conical

B: Broad

C: Chisel

D: Very Broad

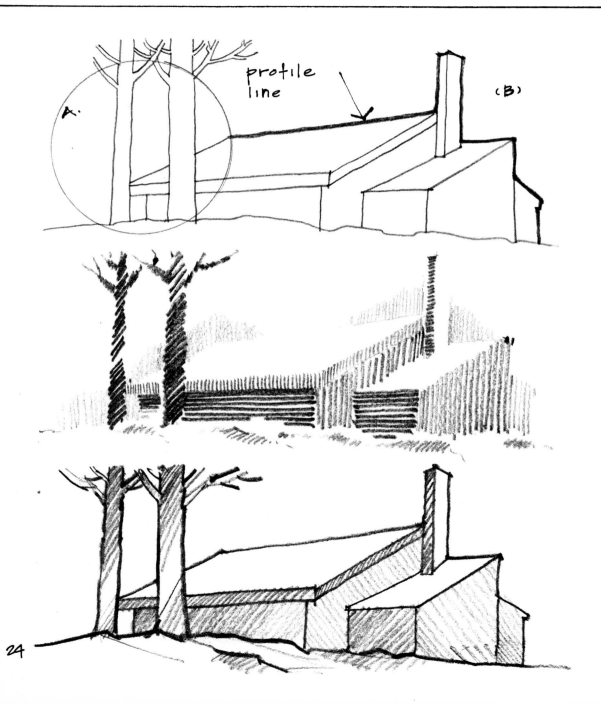

profile
line

A.

(B)

A: Line drawing

B: Line drawing with profile
to differentiate background
and foreground.

Use line of tone to
indicate difference in
planes (looks like
shading).

Line and tone
combined.

24

WITHOUT PROFILE LINE

WITH PROFILE LINE

Simple line drawing

Profile line separates object from background. Object looks more 3-dimensional.

25

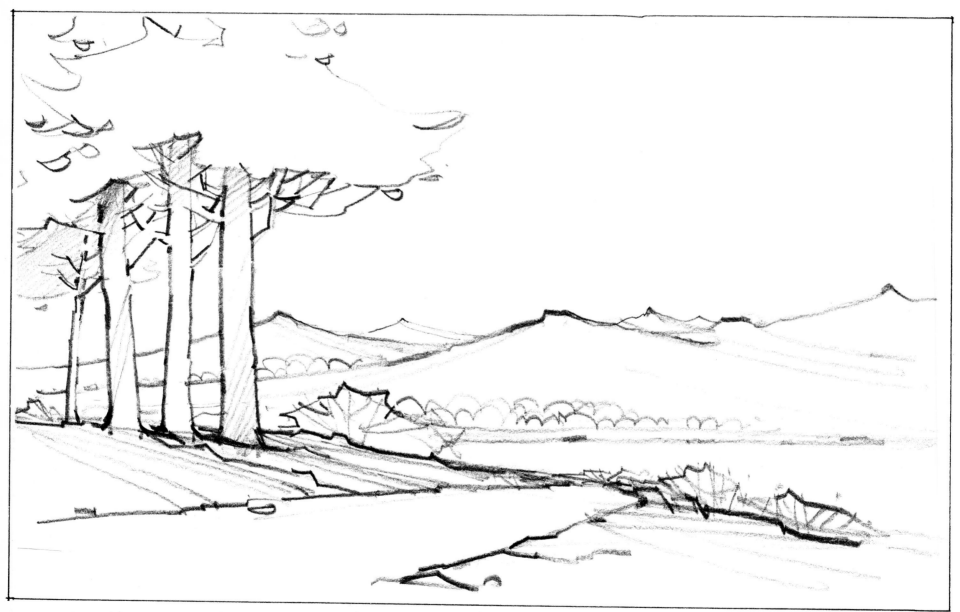

26 IN this example: different line weights suggest different distances. the drawing becomes more 3-D and has depth.

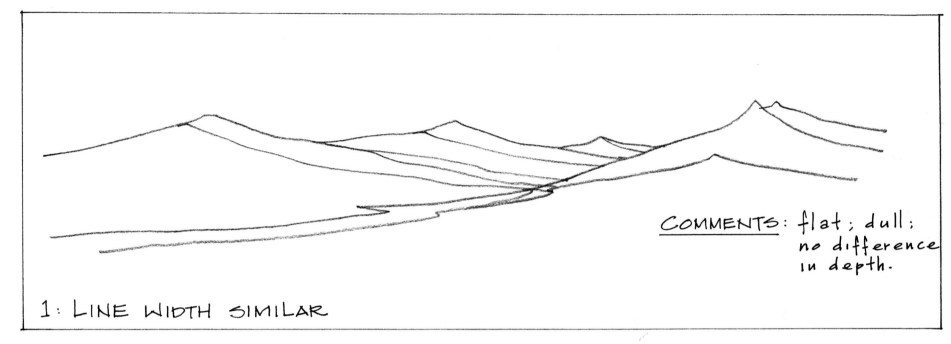

COMMENTS: flat; dull; no difference in depth.

1: LINE WIDTH SIMILAR

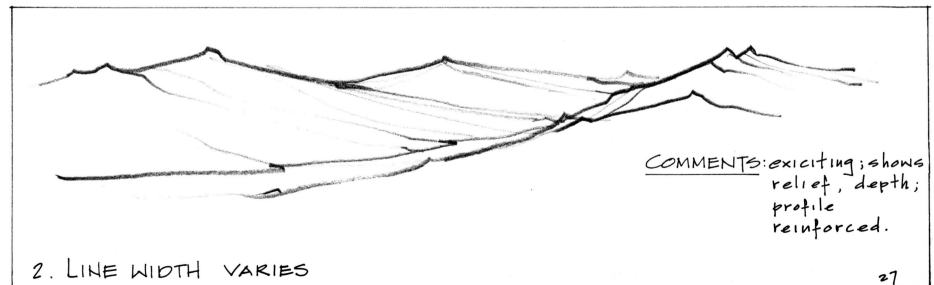

COMMENTS: exiciting; shows relief, depth; profile reinforced.

2. LINE WIDTH VARIES

27

Lighter line defines background.

thick profile lines define massiveness of buildings and bring them out in front of the background (sky and mountain).

thick profile lines define foreground plant materials (shrubs, tree trunks).

Profile line defferentiates building and ground.

Middle ground — building mass as prime subject.

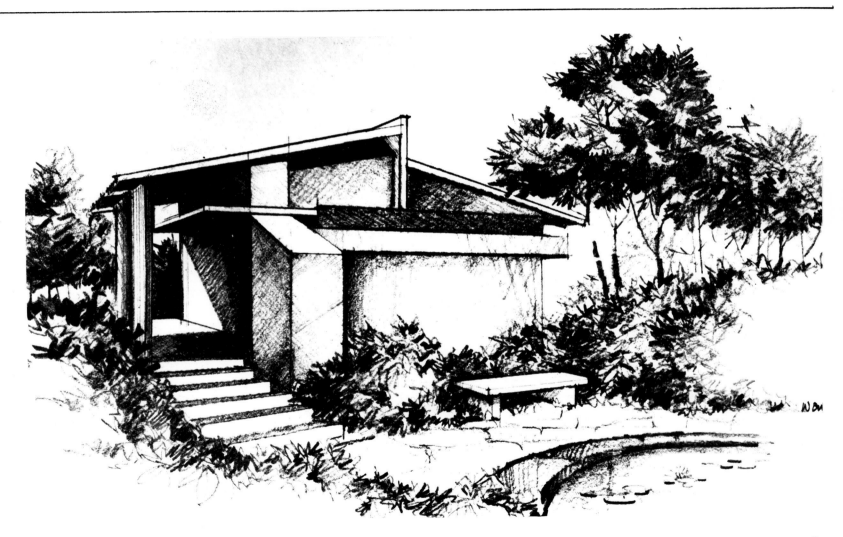

COMPOSITION

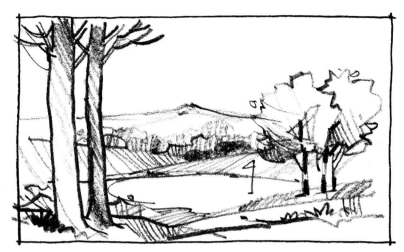

EXAMPLE: Scene of a golf course

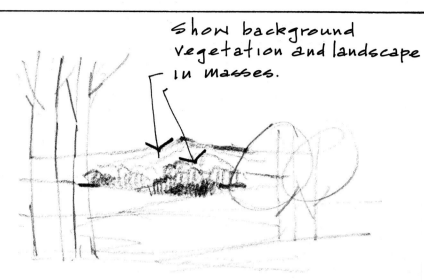

Show background vegetation and landscape in masses.

1. Background

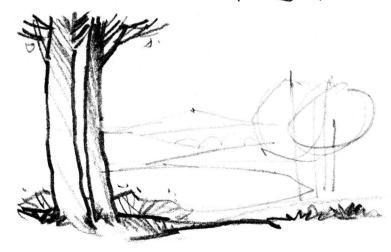

3 - Foreground
 Use as framing; form leads into subject matter;
 Mood setting; should have a lot of details and contrast.

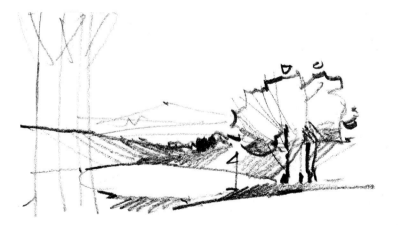

2 - Middle ground
 Usually the theme of the picture; should indicate details.

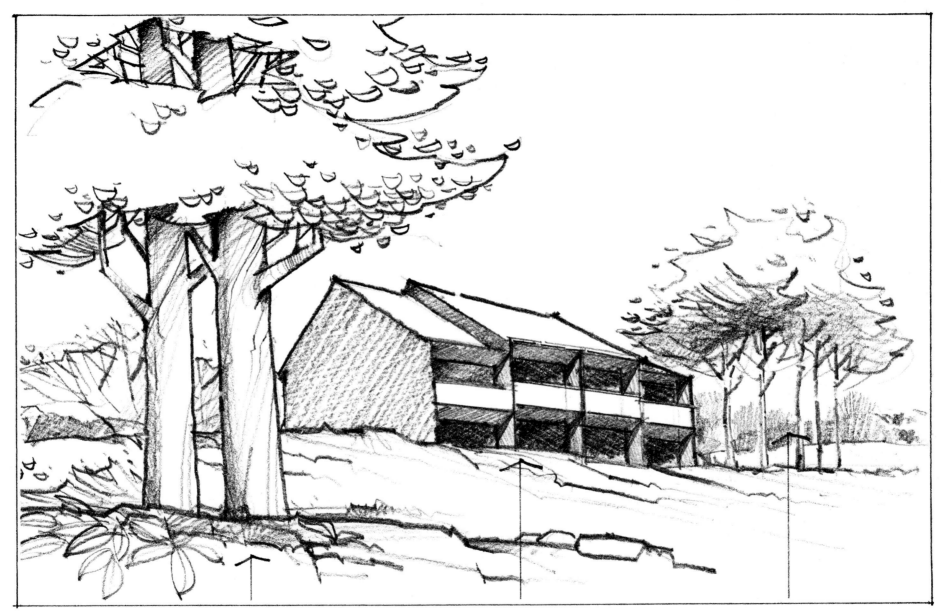

FOREGROUND

MIDDLE GROUND
'theme'

BACKGROUND

 # SHADING

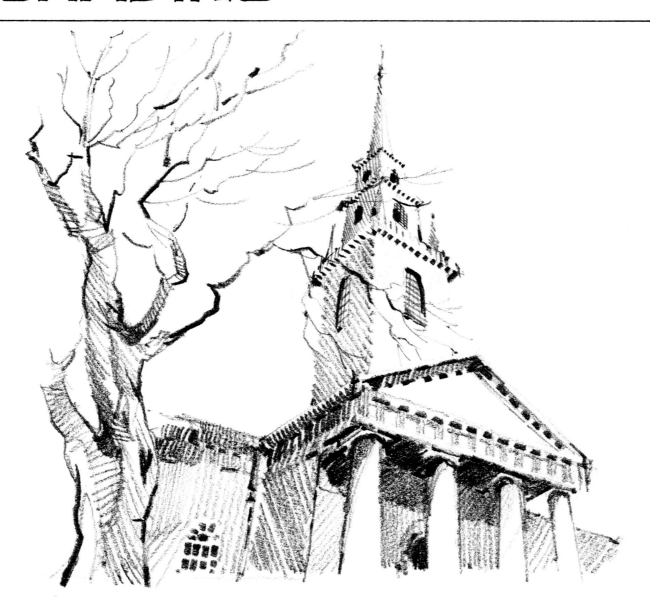

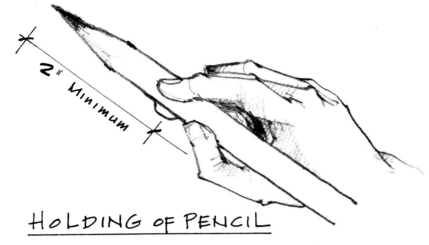

POSITION OF PENCIL

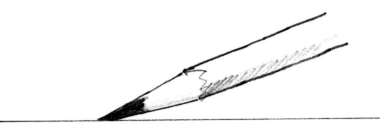

HOLDING OF PENCIL

At least 2" up the tip; relax;
use finger or wrist
movement.

Hold pencil at an angle
(e.g. chisel point or broad stroke)
Use side of lead tip or
broad side of lead for
shading

Coarse; revealing
texture (pencil
strokes).

Smooth (stroke marks
disappear)

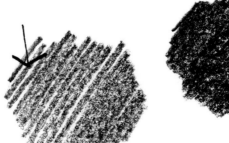

Black, smooth

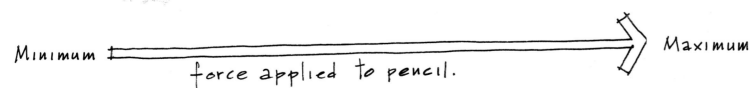

Minimum

Maximum

force applied to pencil.

33

SHADING

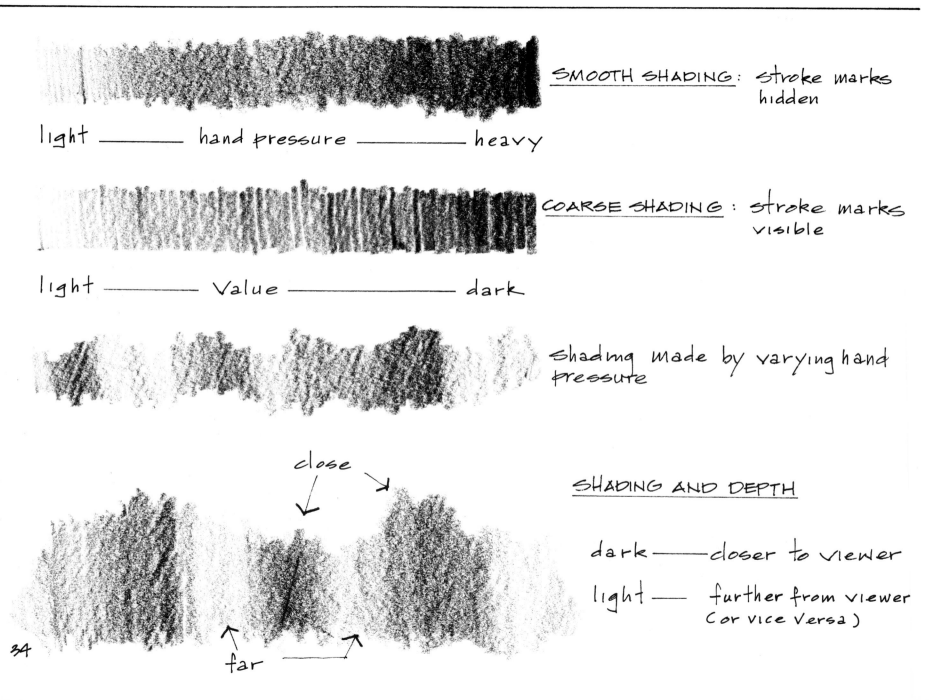

SMOOTH SHADING: stroke marks hidden

light ——— hand pressure ——— heavy

COARSE SHADING: stroke marks visible

light ——— Value ——— dark

Shading made by varying hand pressure

close

far

SHADING AND DEPTH

dark —— closer to viewer

light —— further from viewer (or vice versa)

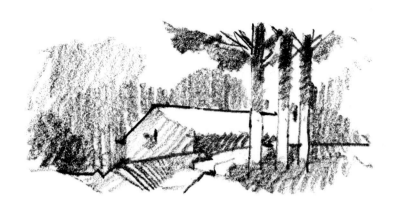

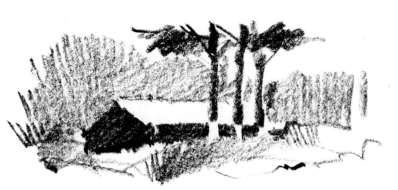

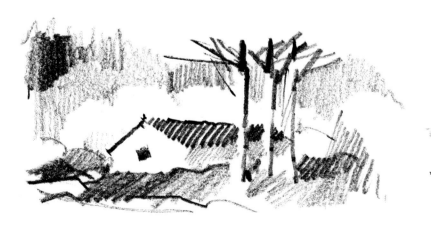

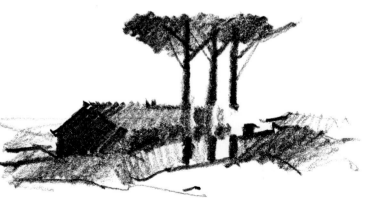

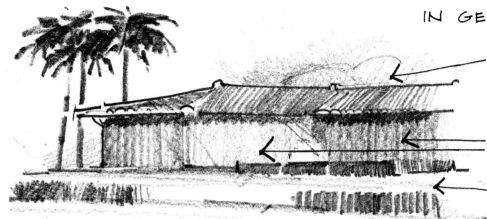

IN GENERAL :

Use diagonal strokes to create texture.

Use vertical strokes to shade vertical planes.

Use horizontal strokes to shade horizontal planes.

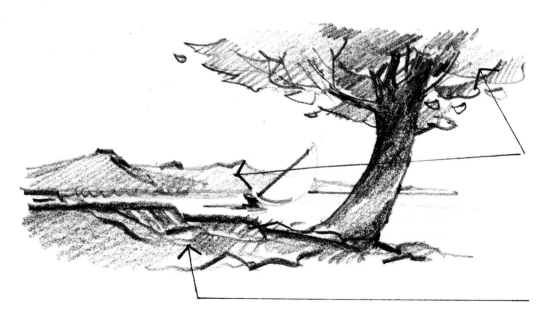

Direction of shading should be consistent.

Stroke direction can vary to reflect the variety of planes (such as rock outcrop in foreground).

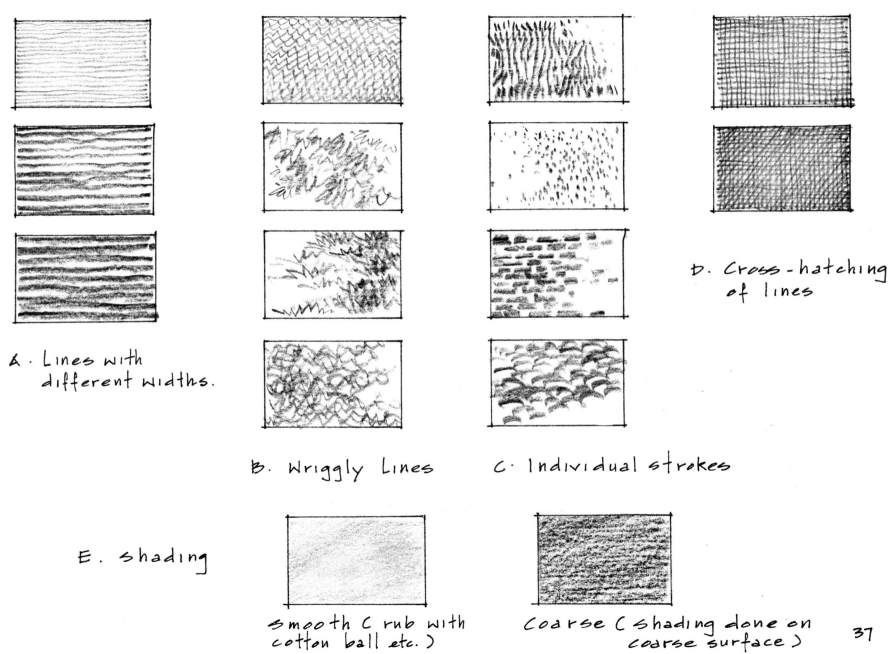

A. Lines with different widths.

B. Wriggly Lines

C. Individual strokes

D. Cross-hatching of lines

E. Shading

smooth (rub with cotton ball etc.)

Coarse (shading done on coarse surface)

37

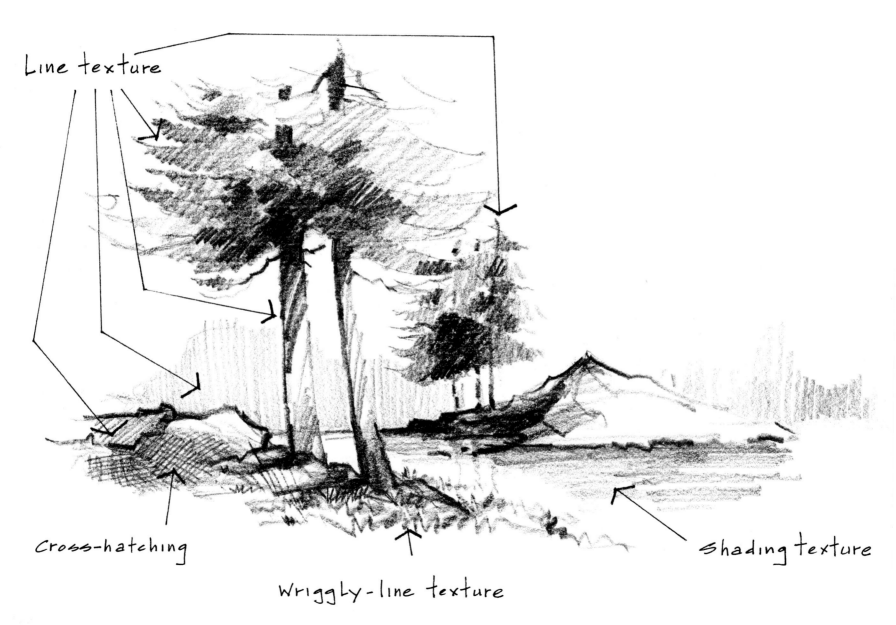

Line texture

Cross-hatching

Wriggly-line texture

Shading texture

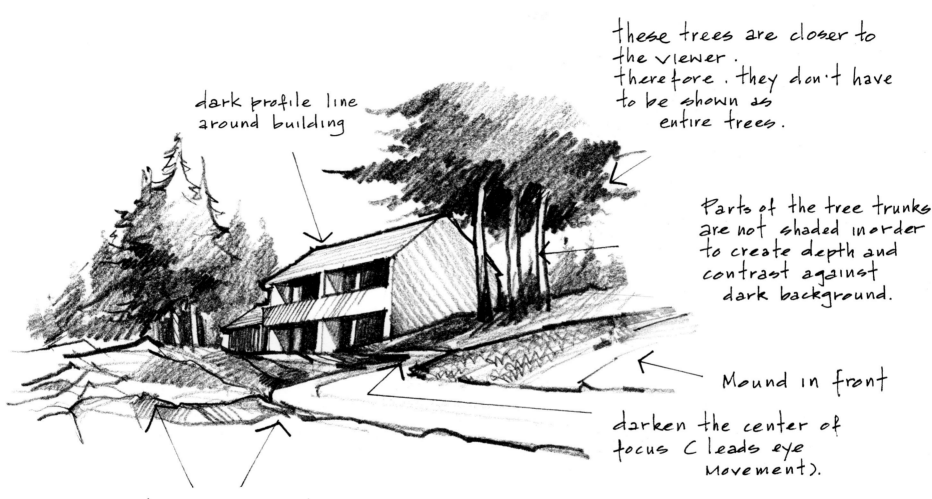

these trees are closer to
the viewer.
therefore. they don't have
to be shown as
entire trees.

Parts of the tree trunks
are not shaded inorder
to create depth and
contrast against
dark background.

dark profile line
around building

Mound in front

darken the center of
focus (leads eye
Movement).

foreground materials (rocks etc.)
should have darker profile lines.

39

 # LANDFORMS

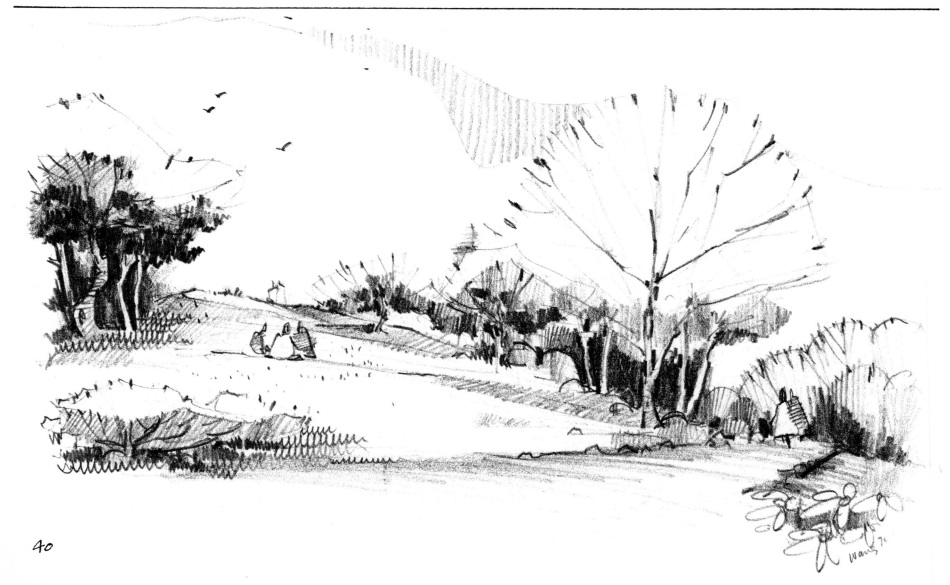

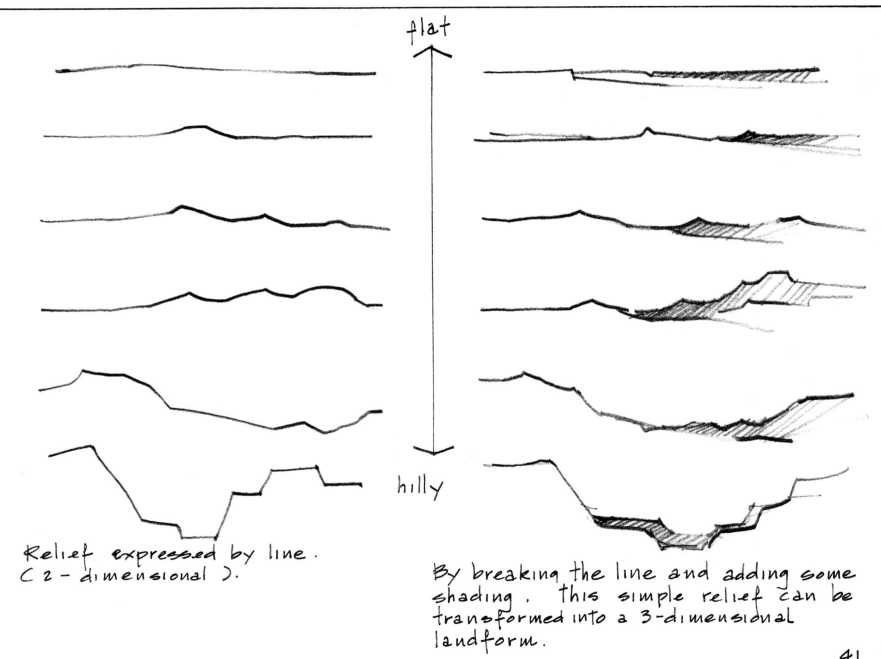

flat

hilly

Relief expressed by line.
(2 - dimensional).

By breaking the line and adding some
shading . this simple relief can be
transformed into a 3-dimensional
landform.

41

step · 1

one continuous line

step · 2

break the line into two
segments

step · 3

add shading to indicate depth
and change the surfaces

step · 4

add more lines:
background lines – lighter
foreground lines – darker

add More shading.

step · 5

Finished !!

step. 1

two lines; begins to show depth.

step. 2

change straight lines into curvilinear lines. this indicates the bending of landform and begins to suggest movement.

step. 3

add shading to indicate depth.

step. 4

darker and heavier foreground lines help to bring out the transition of depth.

additional shading and background filling complete the scene.

step. 5

shading in this case not only suggests depth but also indicates surface materials (smooth/coarse) as well as the change in planes (surfaces).

43

 # 9 VEGETATION

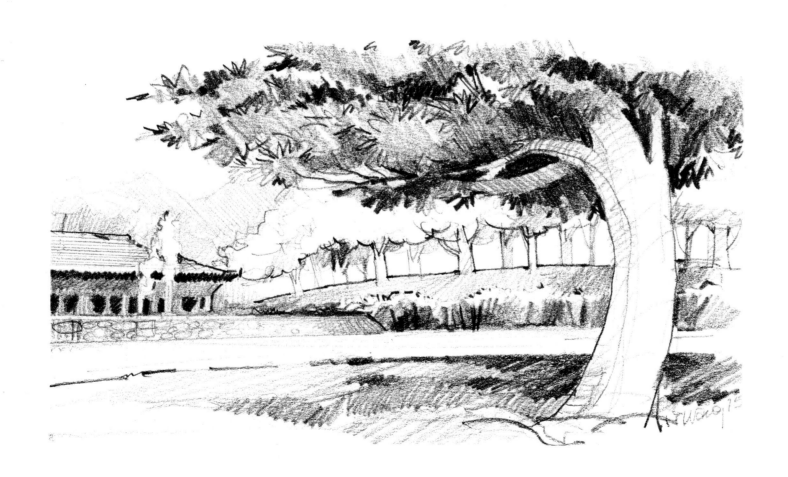

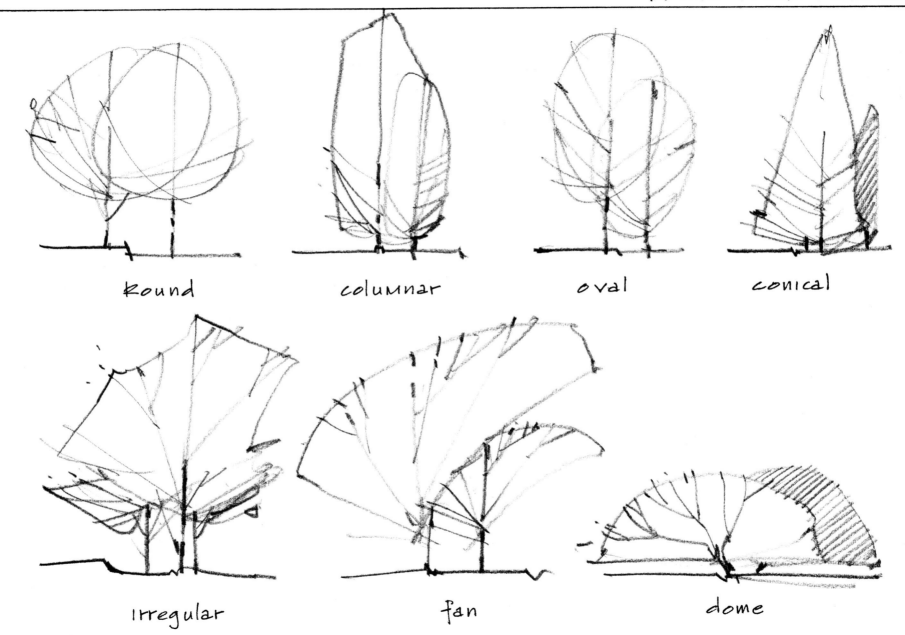

Round columnar oval conical

irregular fan dome

BASIC SHRUB FORMS

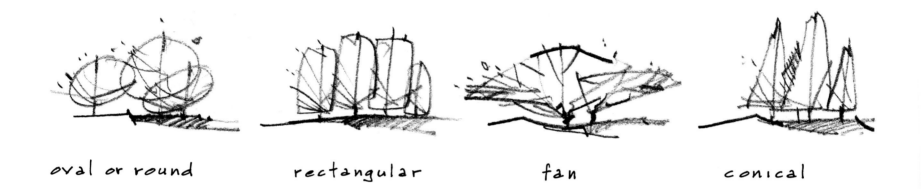

oval or round rectangular fan conical

low, creeping

low, irregular

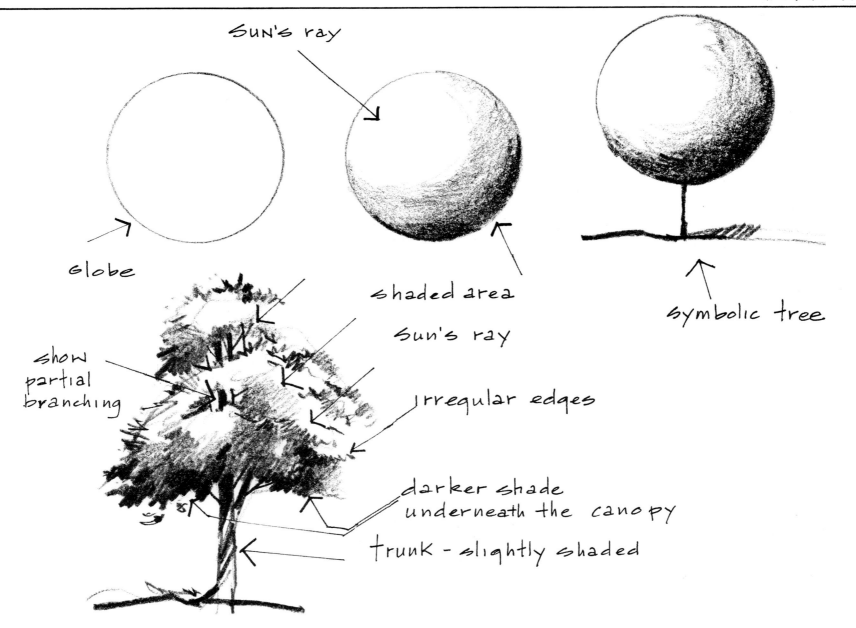

Sun's ray

Globe

shaded area

Sun's ray

Symbolic tree

show partial branching

Irregular edges

darker shade underneath the canopy

trunk - slightly shaded

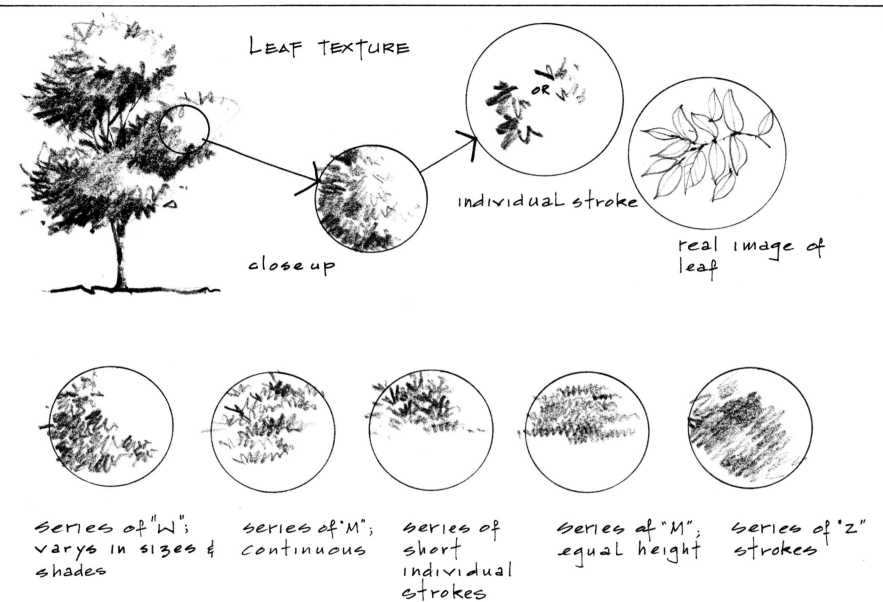

LEAF TEXTURE

close up

individual stroke

real image of leaf

series of "W"; varys in sizes & shades

series of "M"; continuous

series of short individual strokes

series of "M"; equal height

series of "Z" strokes

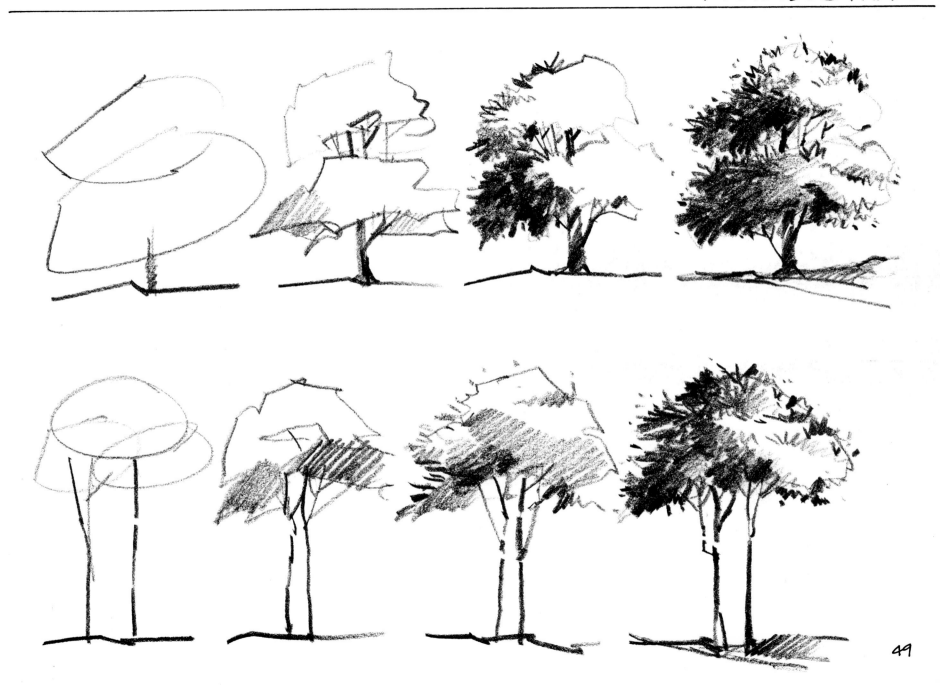

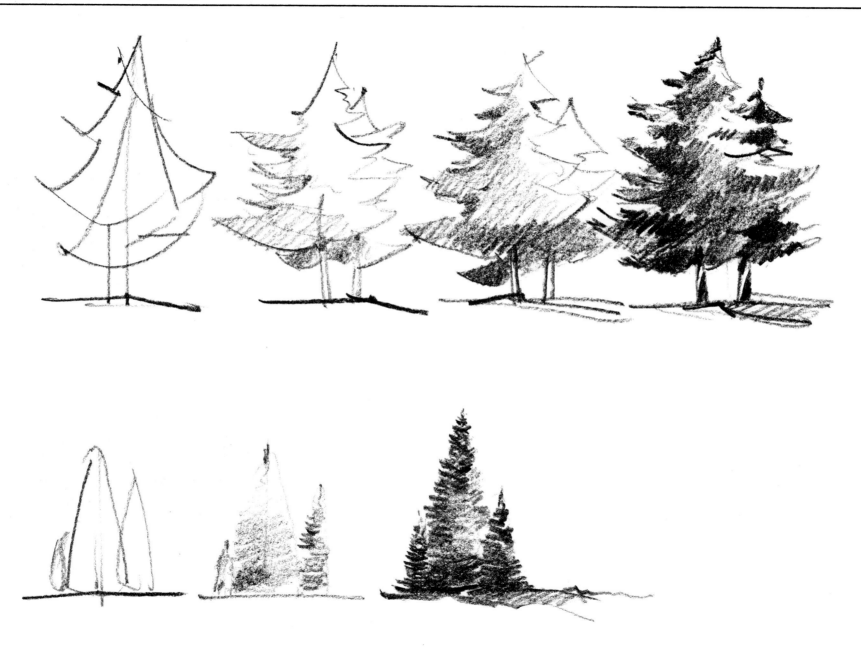

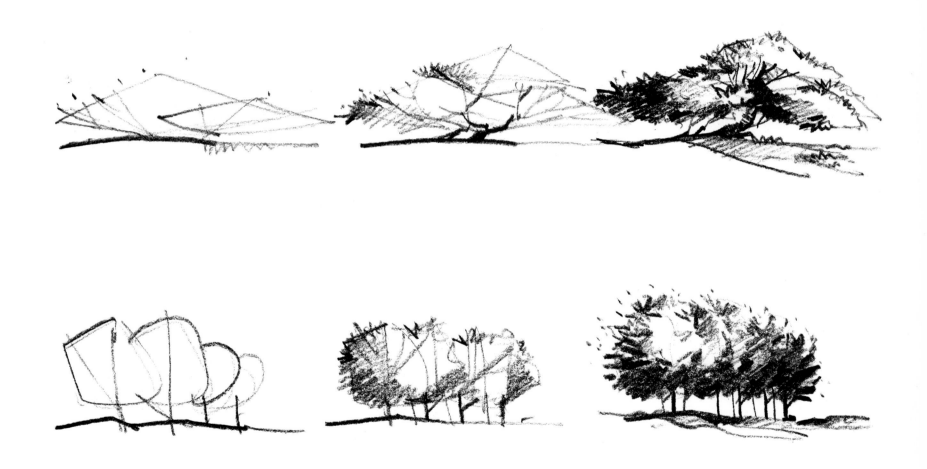

TEXTURAL BUILD-UP INDIVIDUAL PATTERN

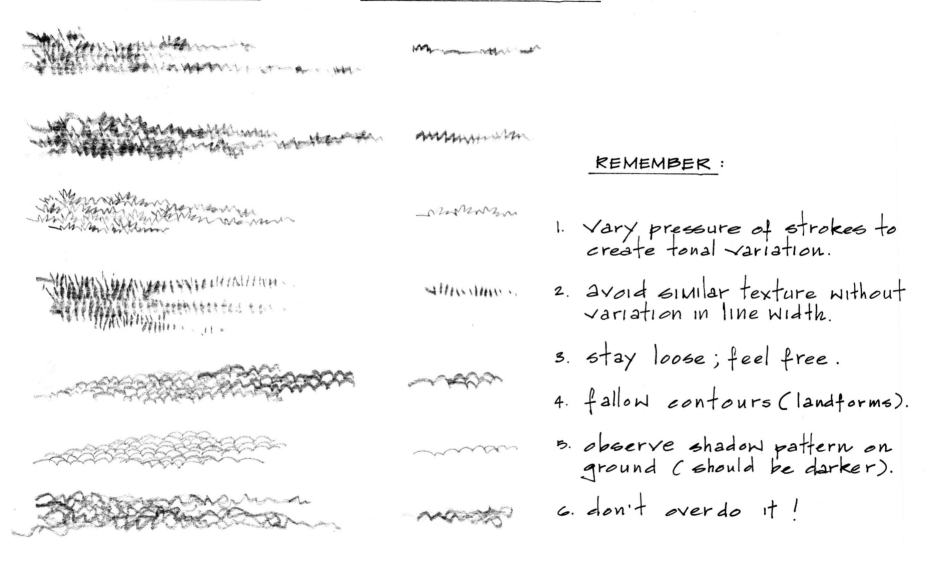

REMEMBER :

1. Vary pressure of strokes to create tonal variation.

2. avoid similar texture without variation in line width.

3. stay loose; feel free.

4. fallow contours (landforms).

5. observe shadow pattern on ground (should be darker).

6. don't overdo it !

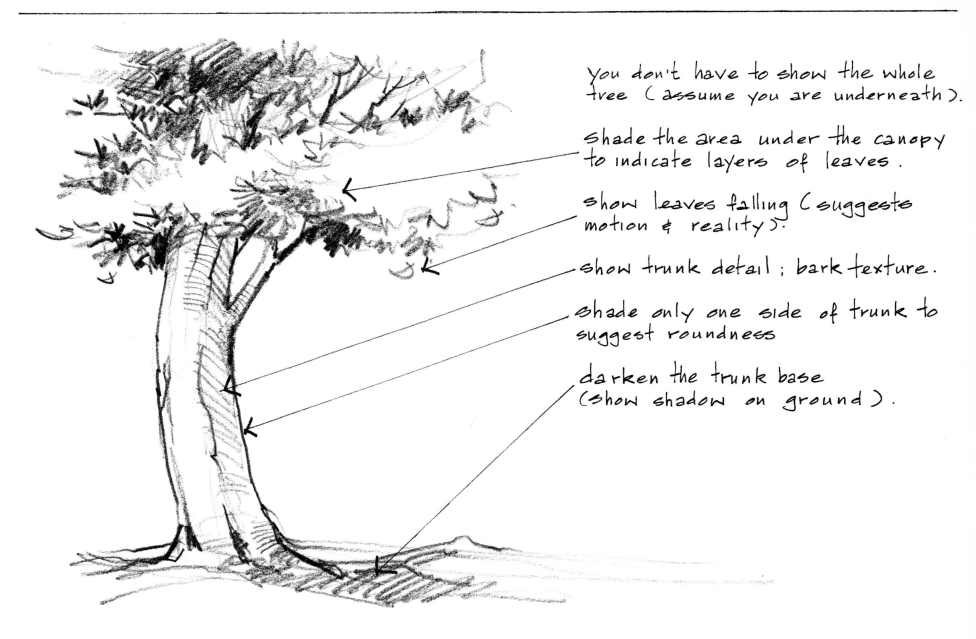

you don't have to show the whole tree (assume you are underneath).

Shade the area under the canopy to indicate layers of leaves.

show leaves falling (suggests motion & reality).

show trunk detail; bark texture.

shade only one side of trunk to suggest roundness

darken the trunk base (show shadow on ground).

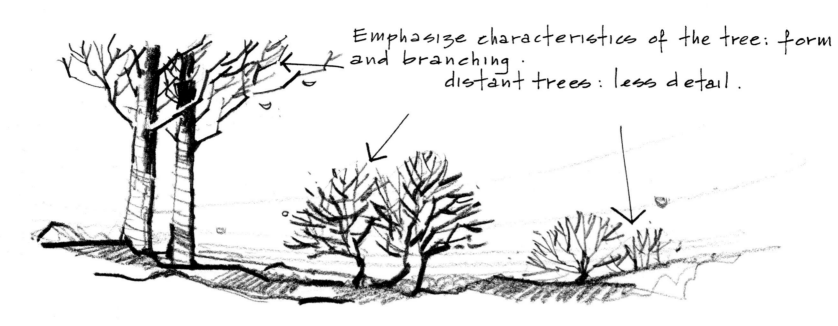

Emphasize characteristics of the tree: form and branching.

distant trees: less detail.

UPRIGHT

HORIZONTAL

DROOPING

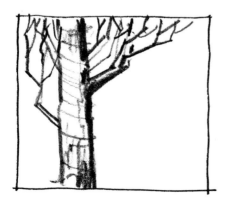

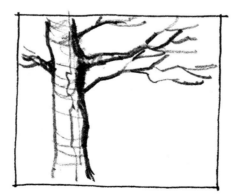

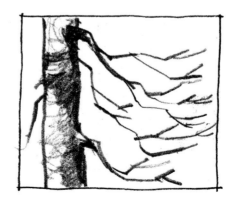

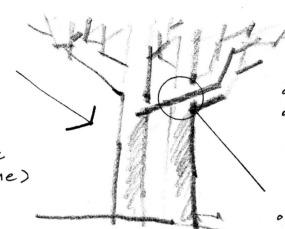

sun

o sketch the basic tree form (outline)

step : 2

o observe sun's rays.
o use thicker and darker line to outline the shaded side of the trunk.

o leave white areas like this to bring out depth.

o begin shading

o add branches.

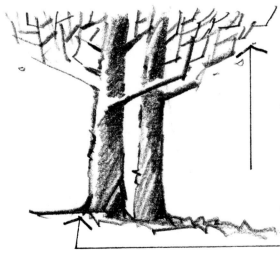

o refine shading.

o add finer branching by using a sharper pencil.

o darken the bottom of the trunk (ground line).

step : 3

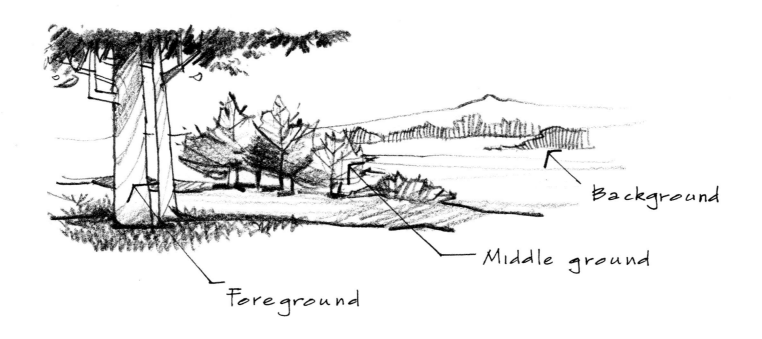

Background

Middle ground

Foreground

Sheet control

balance

framing

lead into
subject matter

light effect

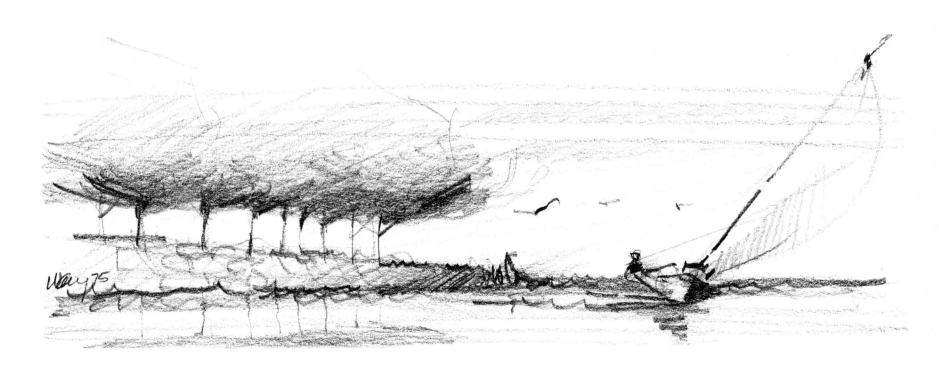

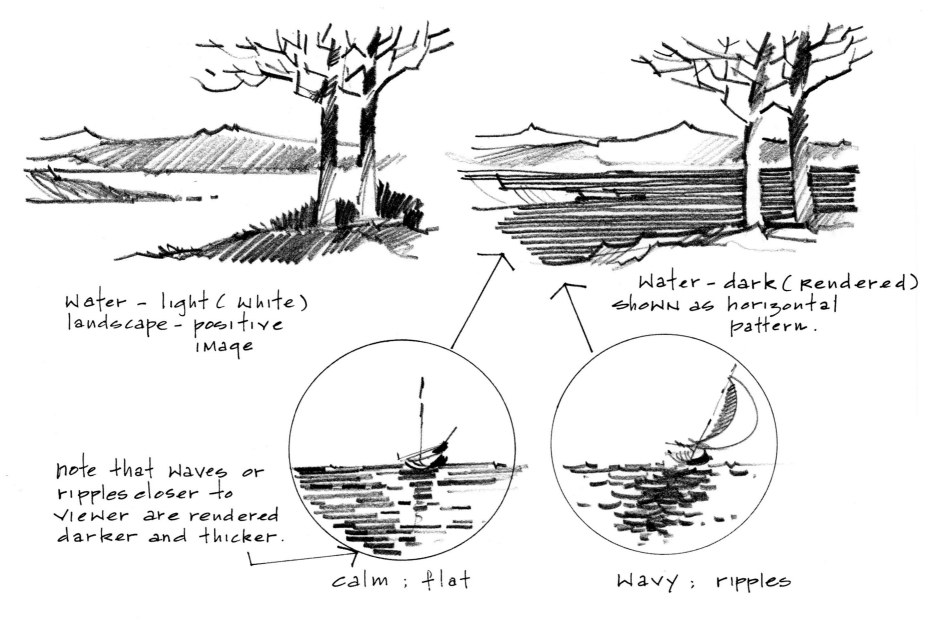

Water - light (white)
landscape - positive
image

Water - dark (Rendered)
shown as horizontal
pattern.

note that waves or
ripples closer to
viewer are rendered
darker and thicker.

calm ; flat

wavy ; ripples

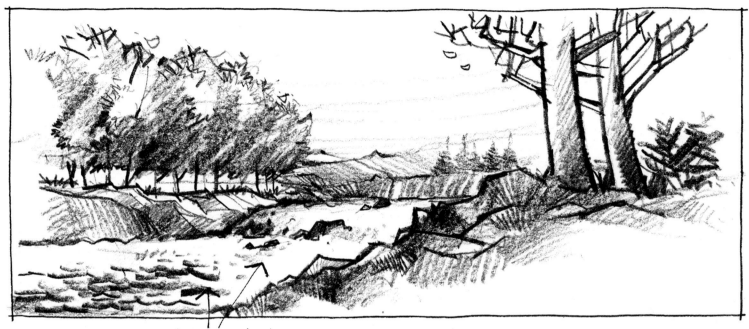

Use short strokes to express wavy water;
leave white areas to indicate waves.

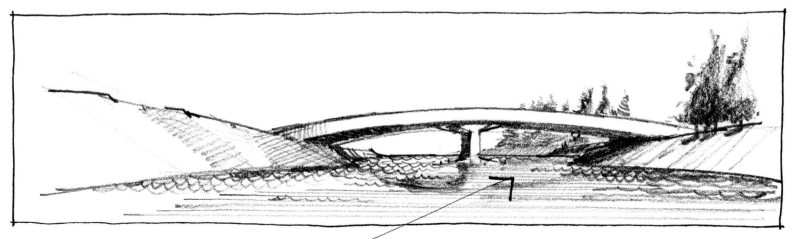

Use long parallel lines to
indicate calm water surface.

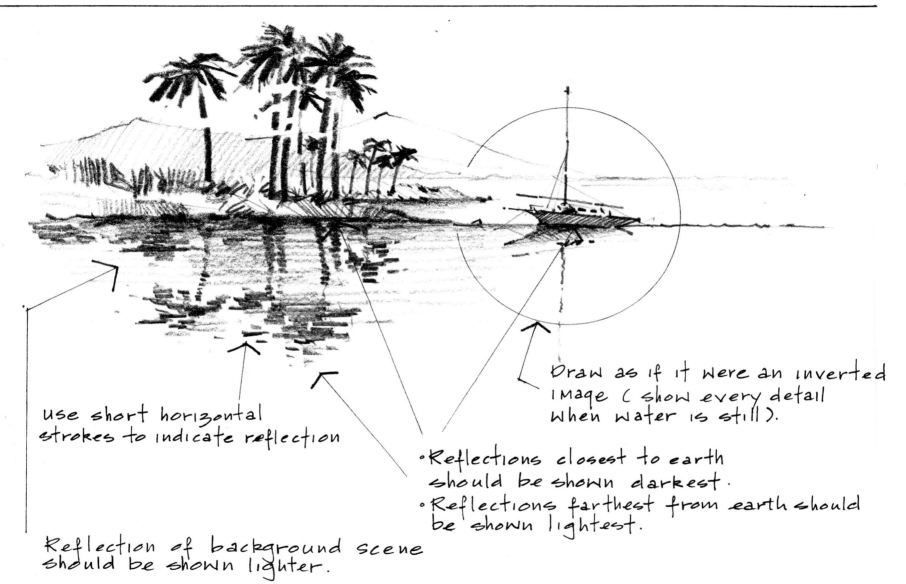

use short horizontal
strokes to indicate reflection

Reflection of background scene
should be shown lighter.

Draw as if it were an inverted
image (show every detail
when water is still).

○ Reflections closest to earth
should be shown darkest.

○ Reflections farthest from earth should
be shown lightest.

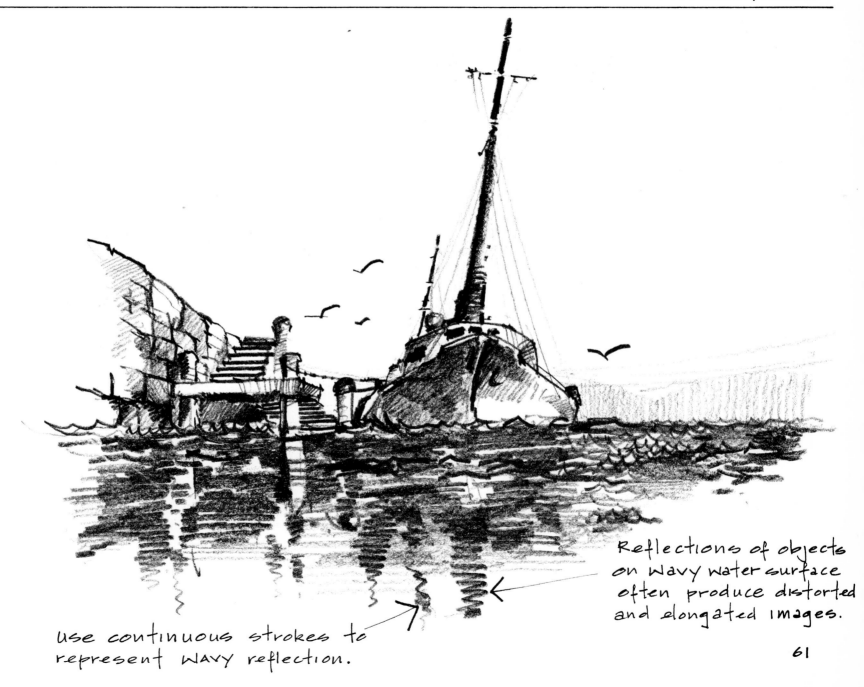

Reflections of objects
on wavy water surface
often produce distorted
and elongated images.

Use continuous strokes to
represent wavy reflection.

61

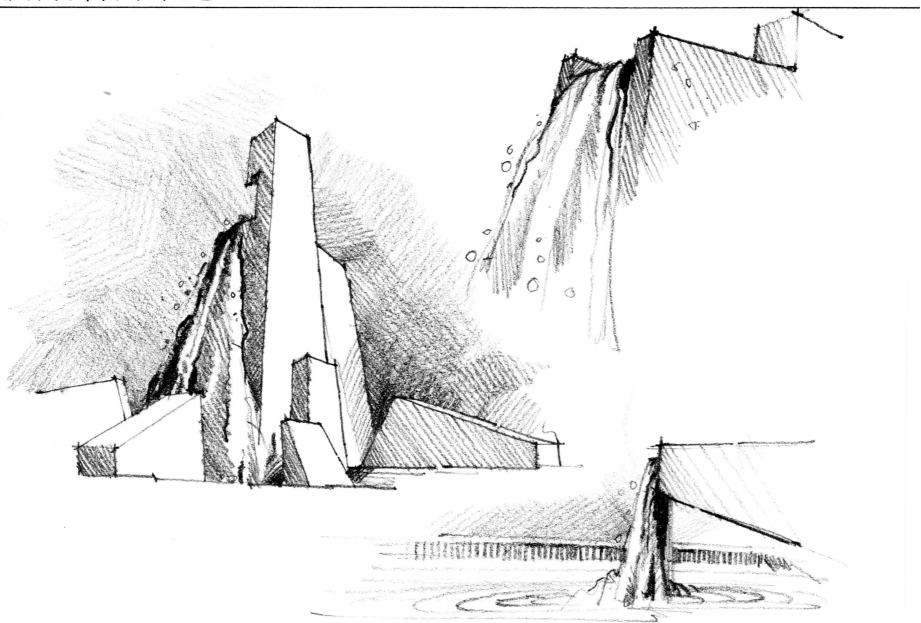

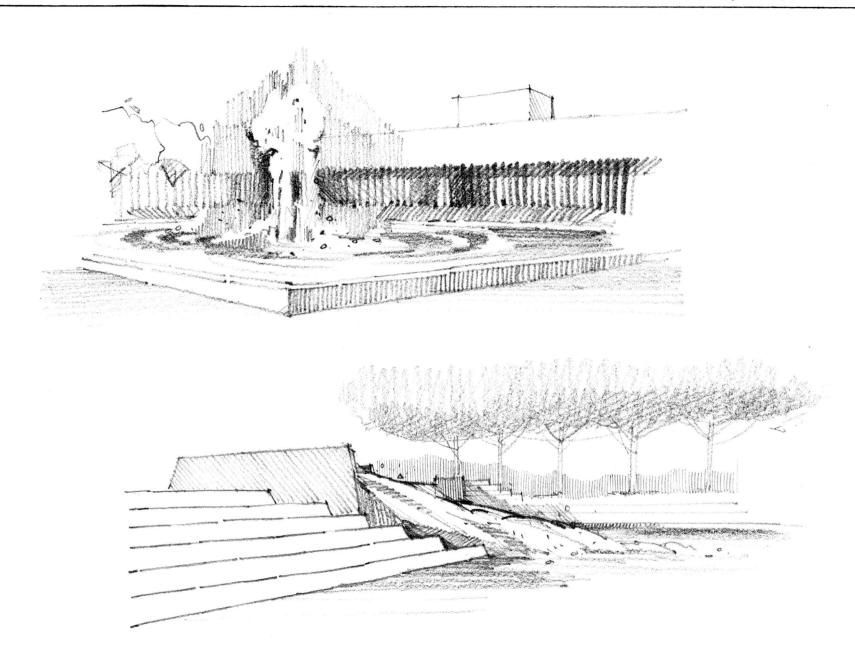

SKY

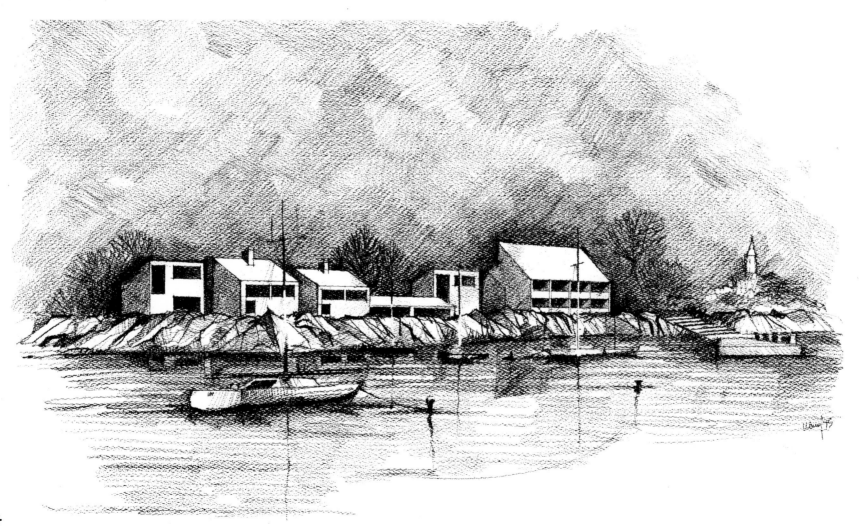

Leave it alone — white

be realistic. show some clouds.

treat it as background —
use texture to fill in the
openness.

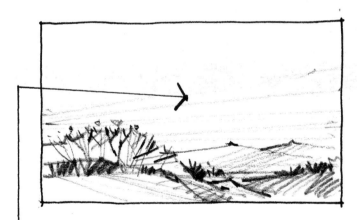

put a few lines across the sky
to fill in the void — symbolic.

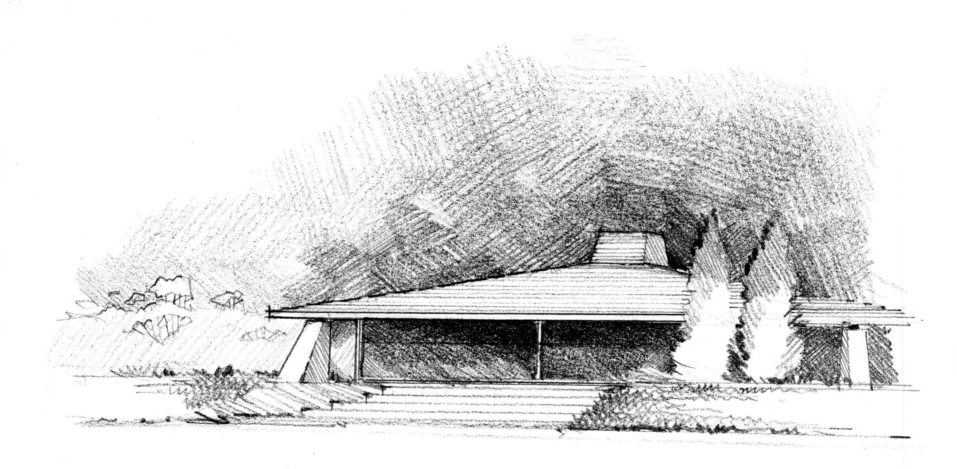

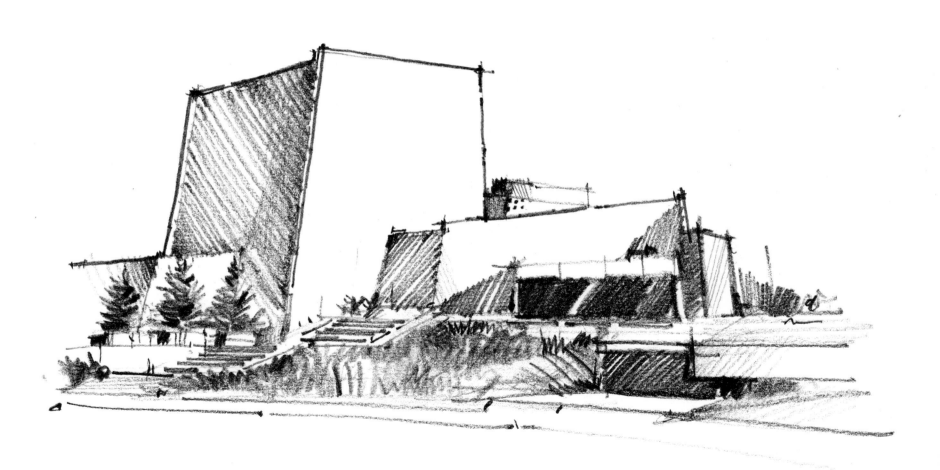

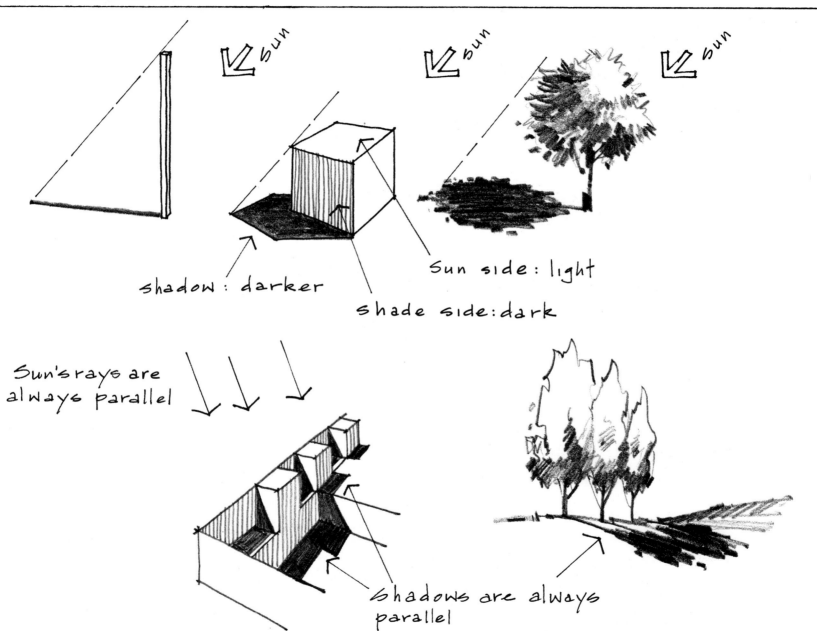

Sun

Sun

Sun

shadow: darker

Sun side: light

Shade side: dark

Sun's rays are always parallel

Shadows are always parallel

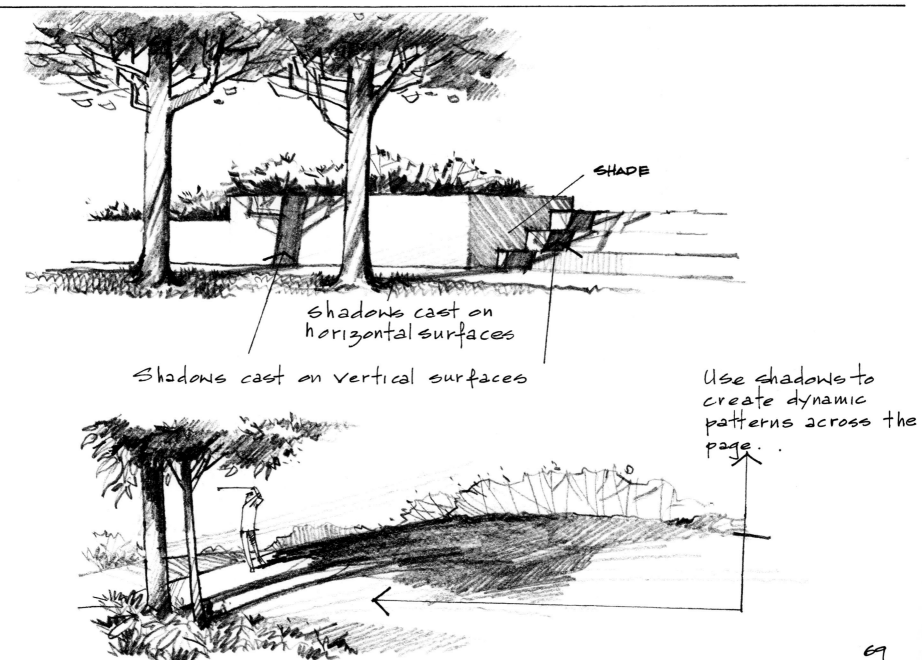

SHADE

Shadows cast on horizontal surfaces

Shadows cast on vertical surfaces

Use shadows to create dynamic patterns across the page. . .

69

 # BUILDINGS

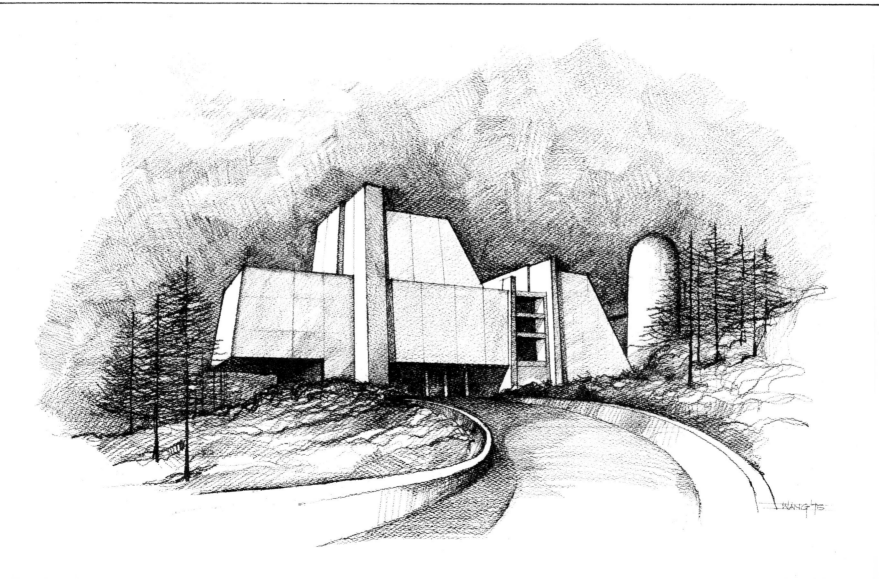

Transformation of a cube

Increase in: Complexity of planes
Complexity of dark & light contrast

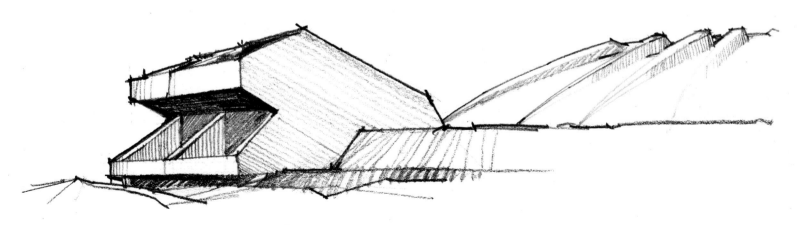

Forms become more complex.

Sun coming from top (to the left) at high angle behind building.

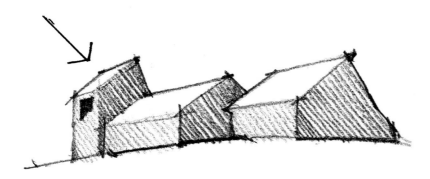

Sun coming from the right side at low angle.

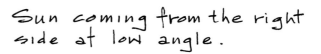

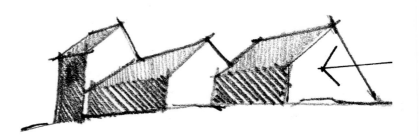

Sun coming from behind the building.

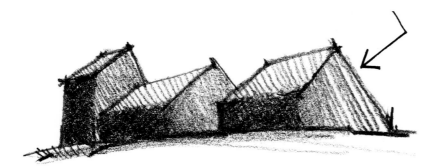

Sun coming from the front.

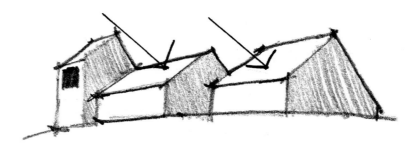

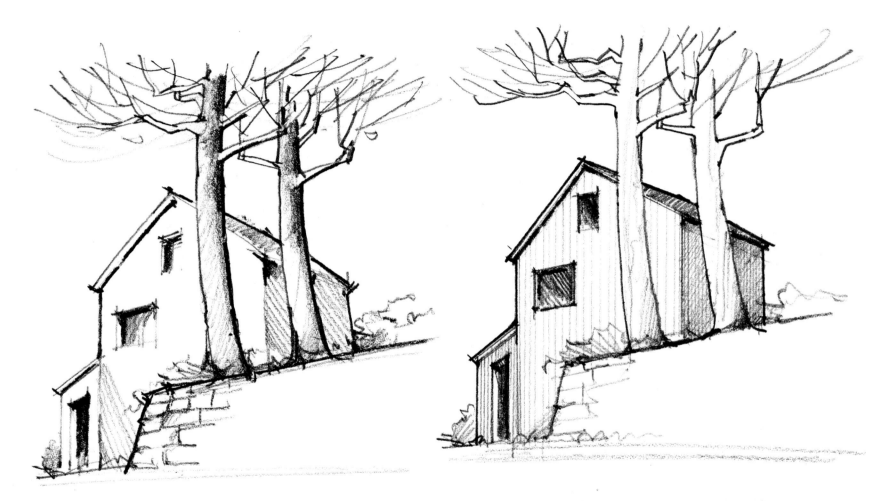

Building and landscape are both in sketchy, loose style.

Building: hard edge; detailed. landscape: soft edge; loose.

An attempt to emphasize the architecture & downplay the landscape.

73

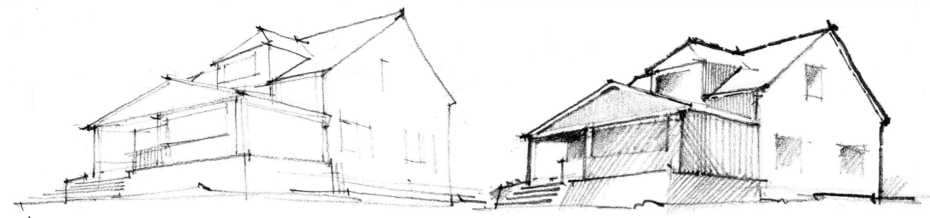

step: 1

- Outline the building (basic form)
- adjust perspective
- locate all details (door/window)

Step: 2

- Outline the building with profile line
- observe sun's orientation
- shade the planes that are in shades
- staighten the lines

step: 3

- Refine shading
- clean up shading errors with a good eraser and erasing shield
- use a sharp pencil to touch up the edges and details
- add background and foreground

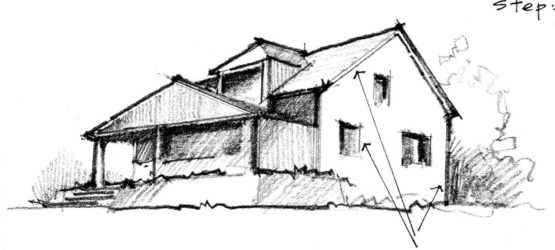

examples of touch-up

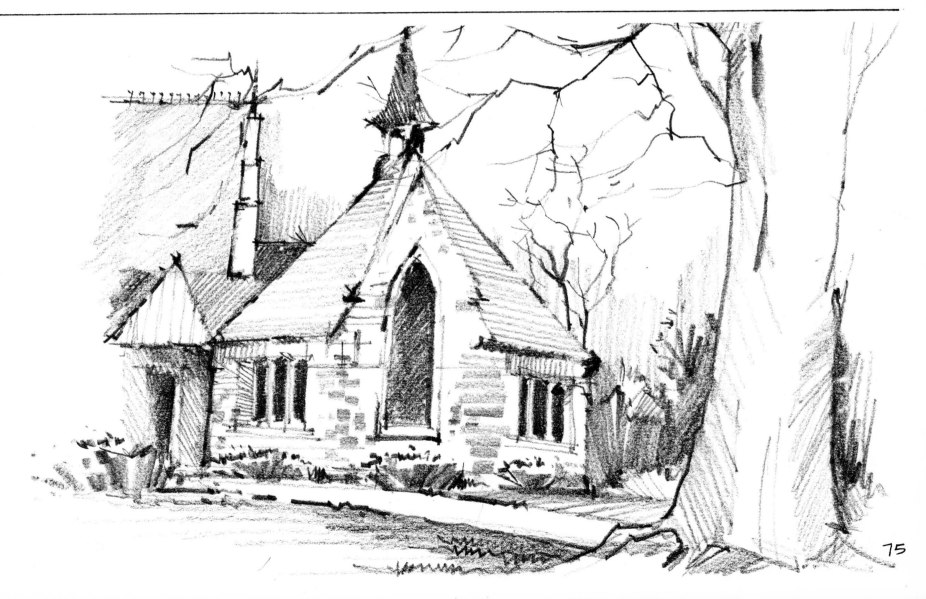

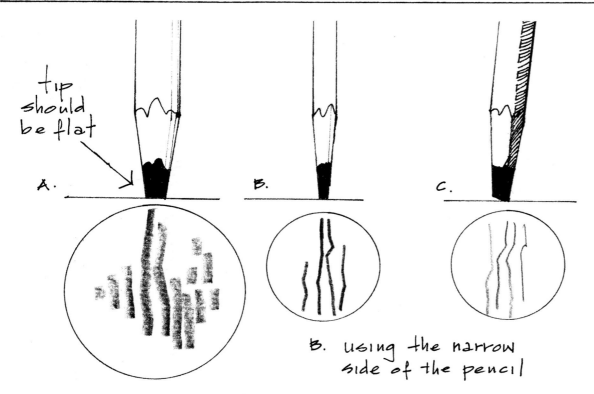

tip
should
be flat

A.

B.

C.

By holding the pencil at various angles (by rotating it), you can get a variety of line widths from this kind of sketching pencil.

B. using the narrow side of the pencil

C. holding the pencil sideways and using the corner of the tip.

A. using the broad side of the pencil.

* Fundamental stroke exercises

Ordinary round
sketching pencil.

Pencil with
rectangular
lead.

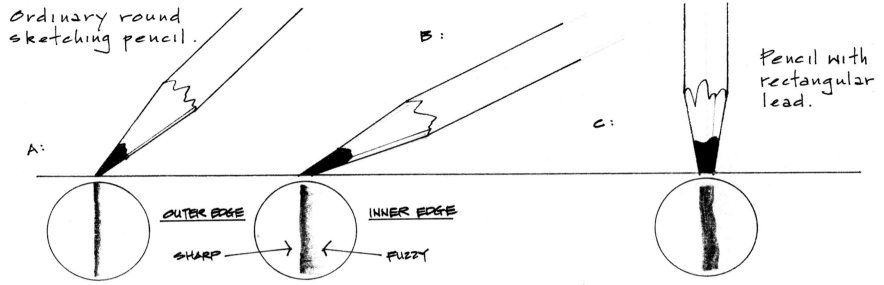

A:
B:
C:

OUTER EDGE INNER EDGE

SHARP → ← FUZZY

Comments:

It is difficult to maintain
consistent line width unless
your grip and pencil angle are
also consistent.

The outer side of the line tends
to be sharper than the inner
side.

The width of the broad stroke
depends on the angle at which
you hold the pencil.

Comments:

The flat sketching pencil are slightly
difficult to get used to, and they
are not as flexible as ordinary
round pencils.

The advantage of this kind of pencil
is that one can maintain consistent
line width and tone.

Of course, the width of the broad
stroke depends on the width of
the lead tip.

Example: A

Example : B

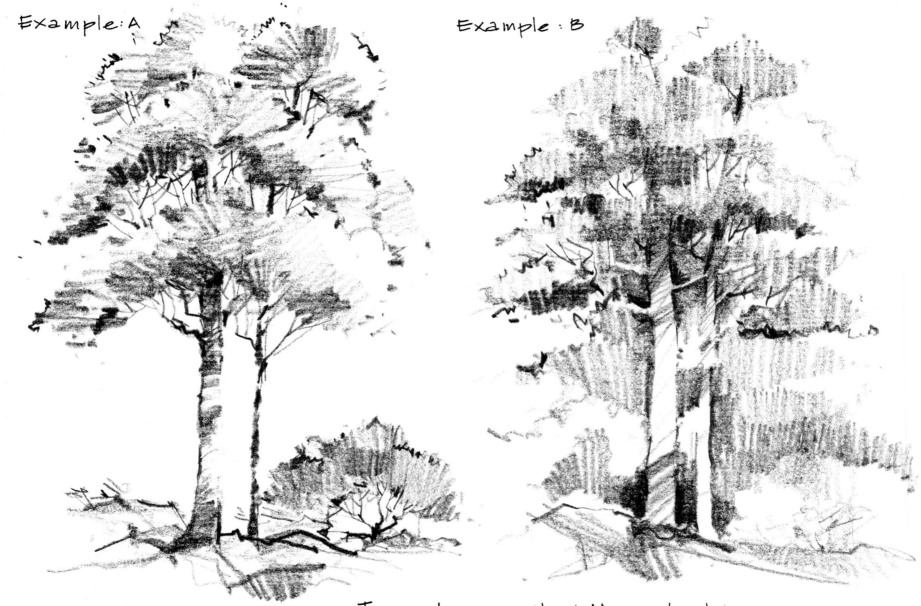

Tree shown with different styles
of broad strokes

Broad strokes and
tree trunks.

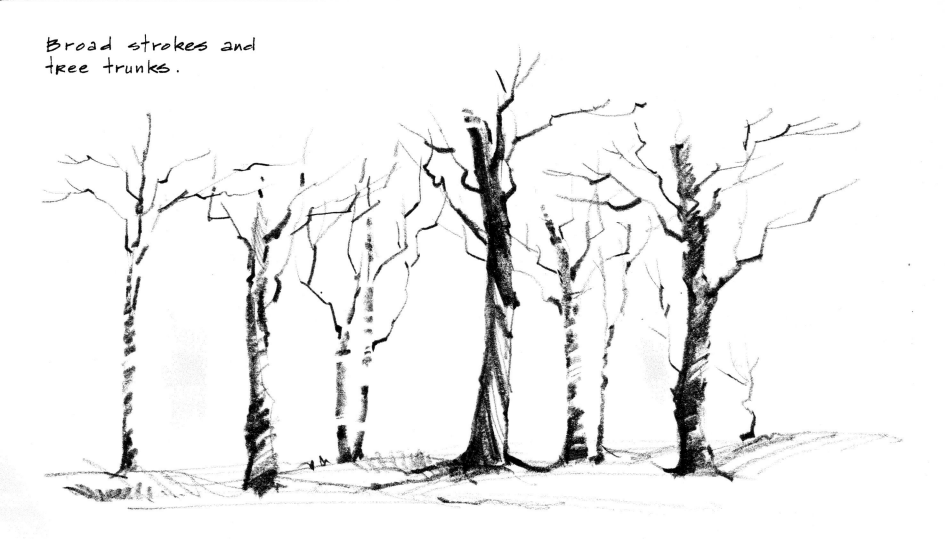

Use individual strokes (horizontal, vertical, or
diagonal) for major structure; leave some white
areas to indicate the roundness of tree trunk;
use corners of the lead tip for fine branching
structure.

79

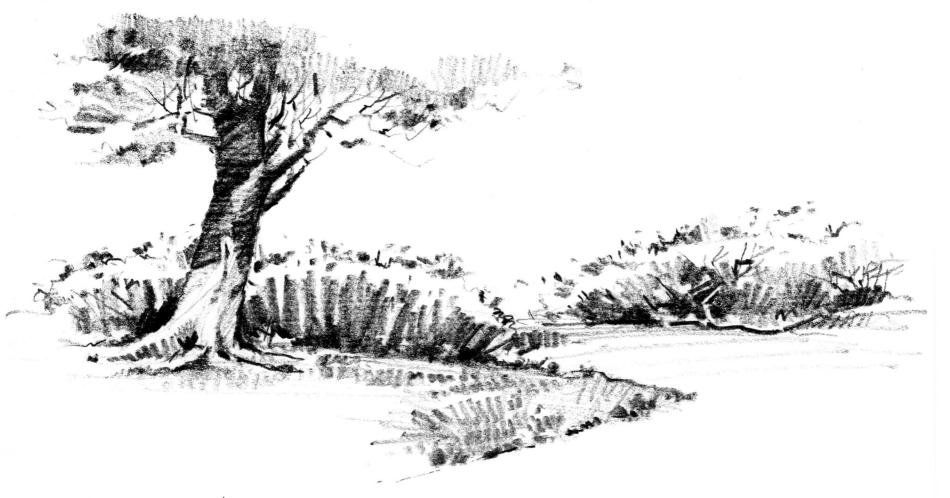

Use flat sketching pencil as if you're painting with an oil painting brush.
The beauty of broad-stroke sketching is to reveal all strokes as they
gradually build up the texture.
The sketch should be a composite of strokes in various widths
instead of lines.

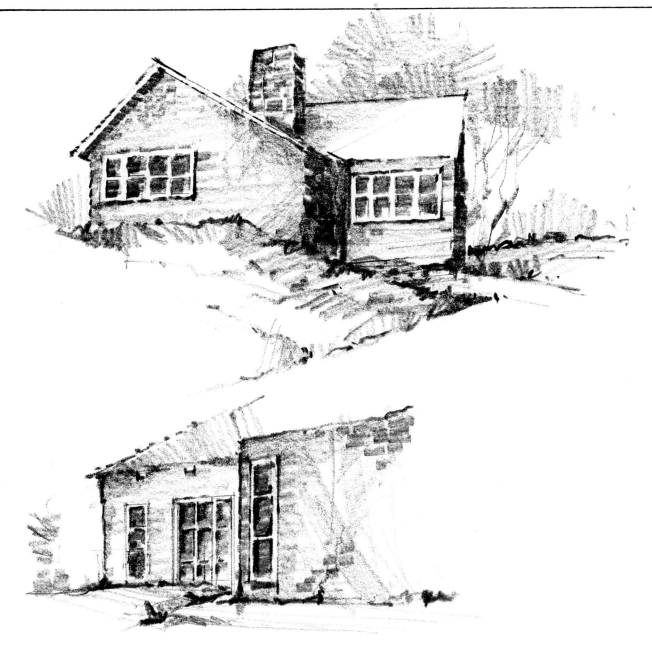

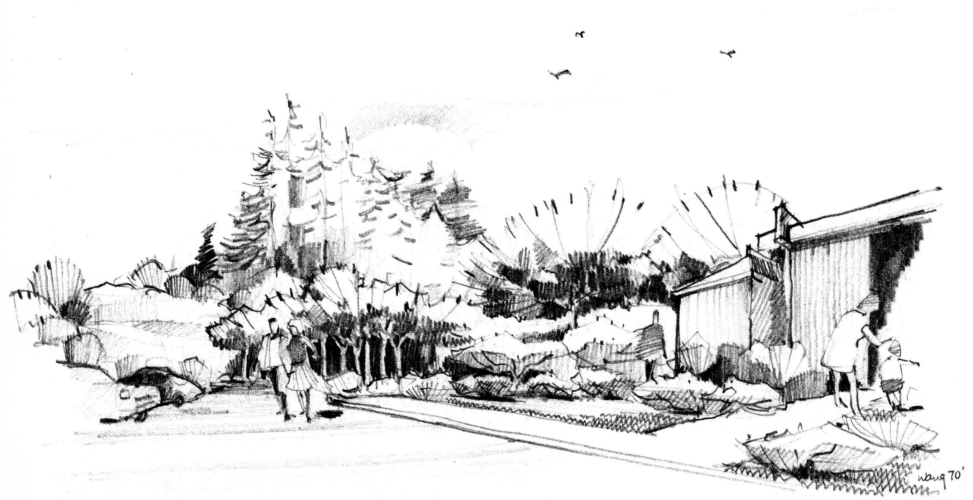

Average adult child

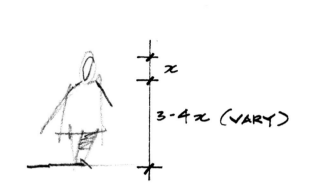

$2Y$

Y

1

1.5

x

$5-6x$

x

$3-4x$ (VARY)

1. PROPORTION

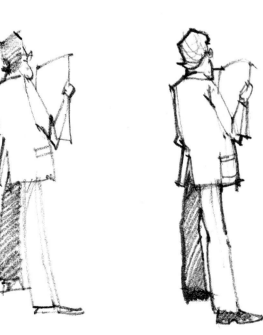

note:

degree of detail should be relevant to the whole picture context (i.e. a rough, sketchy drawing will not work well with nicely drawn figures).

83

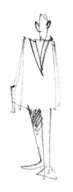
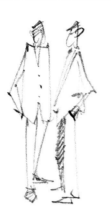
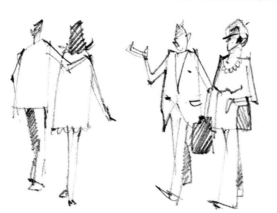
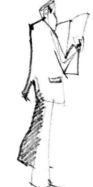
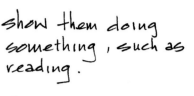

show them doing
something, such as
reading.

show people with
gestures such as
waving hands or
hands in pocket.

don't always show
individual figure

show people
engaged in talking

show back
view as well
as front

show them
carrying things in
their hands

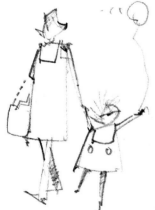
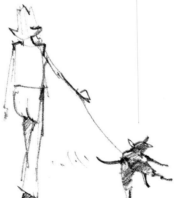
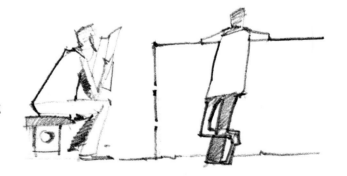

show background
figures in groups

show both sexes and kids.
show children in action

show people walking dogs.
pushing baby carts etc.

If design permits, show
figures sitting, leaning
against wall or sitting on
top of wall.

All these suggest human relationships, friendship. they are realistic and make the
people belong to the entire picture.

Symbolic realistic

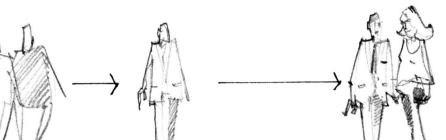 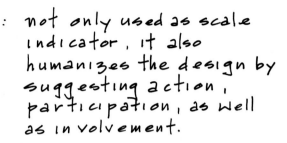

: not only used as scale
 indicator, it also
 humanizes the design by
 suggesting action,
 participation, as well
 as involvement.

: used as scale indicator
 or for background

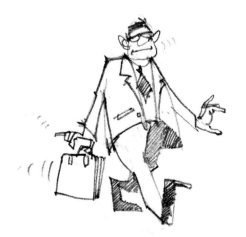

Ocassionally, cartoon like figures are
good for a certain kind of sketch
because they enhance the feeling of
the drawing.

However, they should be used carefully
so that they will not overpower the
main theme of the drawing.

Use cartoon like figures only when
the subject matter is appropriate.

85

Show fianres dressed in contempory styles. Update your knowledge of fashions.

Show a variety of characters.

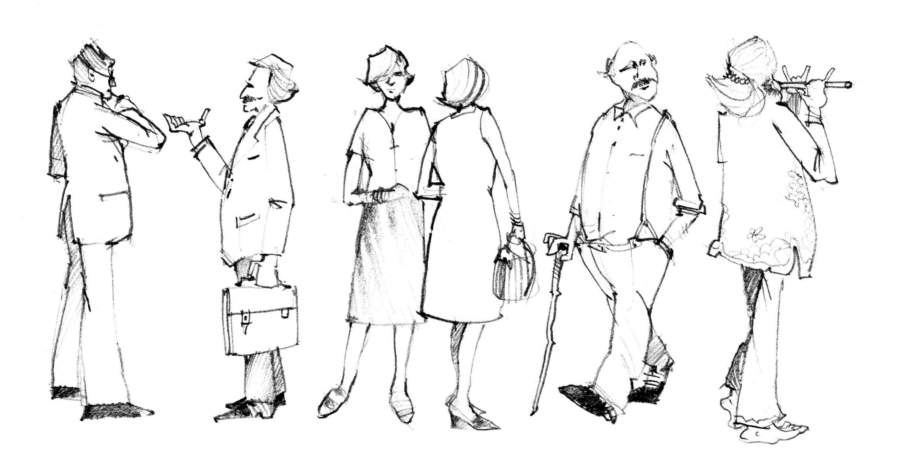

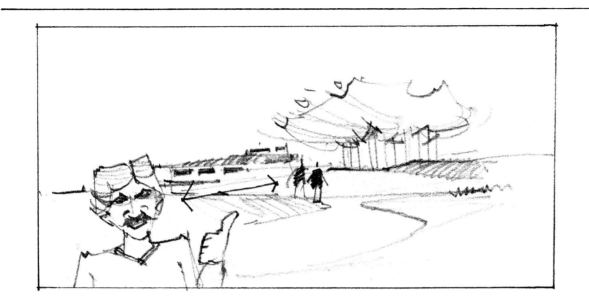

Avoid oversized figures in foreground

Avoid abrupt change in the scale of figures. (from foreground to background or vice versa.)

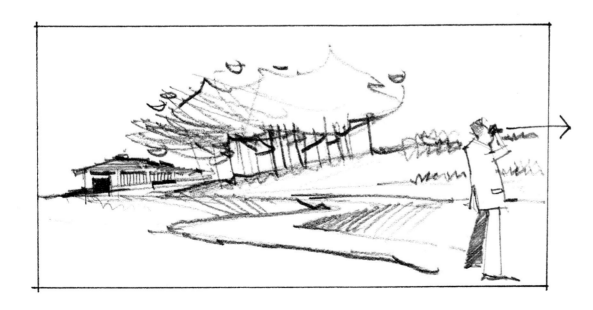

Avoid showing action that flows beyond the page content (for example: taking picture that doesn't exist within the frame).

Relate figures to subject matter and content.

Relate figures to: locations.
time of day.
seasons.
race.
age groups etc.

87

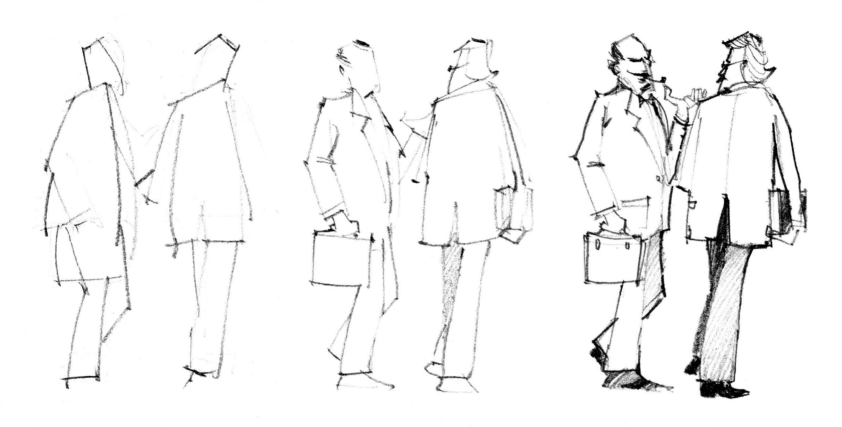

step 1:
 show outline.
proportion, and
gesture.

step 2:
 refine outline.

step 3:
 add details,

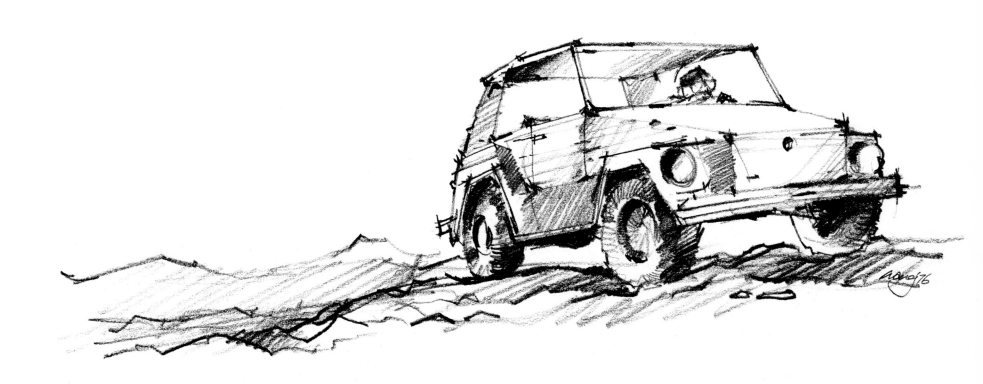



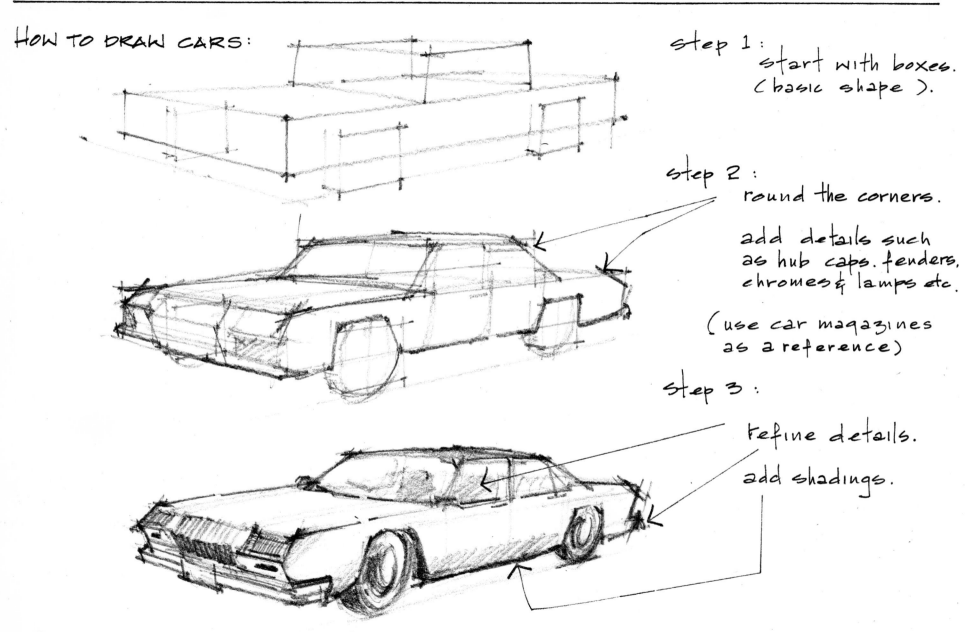

HOW TO DRAW CARS:

step 1:
start with boxes.
(basic shape).

step 2:
round the corners.

add details such
as hub caps. fenders,
chromes & lamps etc.

(use car magazines
as a reference)

step 3:
refine details.
add shadings.

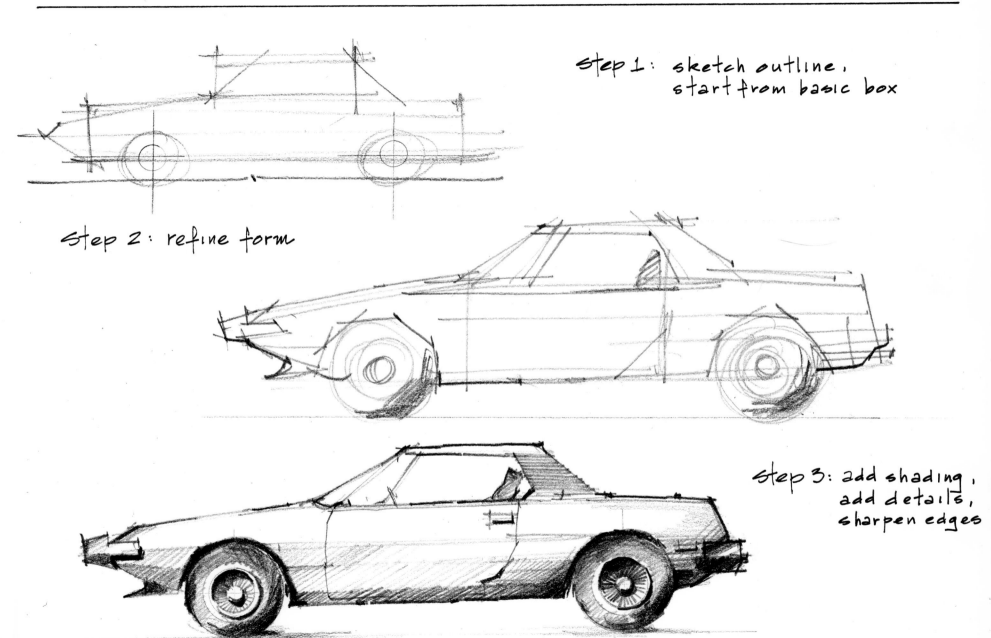

Step 1: sketch outline,
start from basic box

Step 2: refine form

Step 3: add shading,
add details,
sharpen edges

CARS IN PERSPECTIVE

Different ways to show cars:

shading →

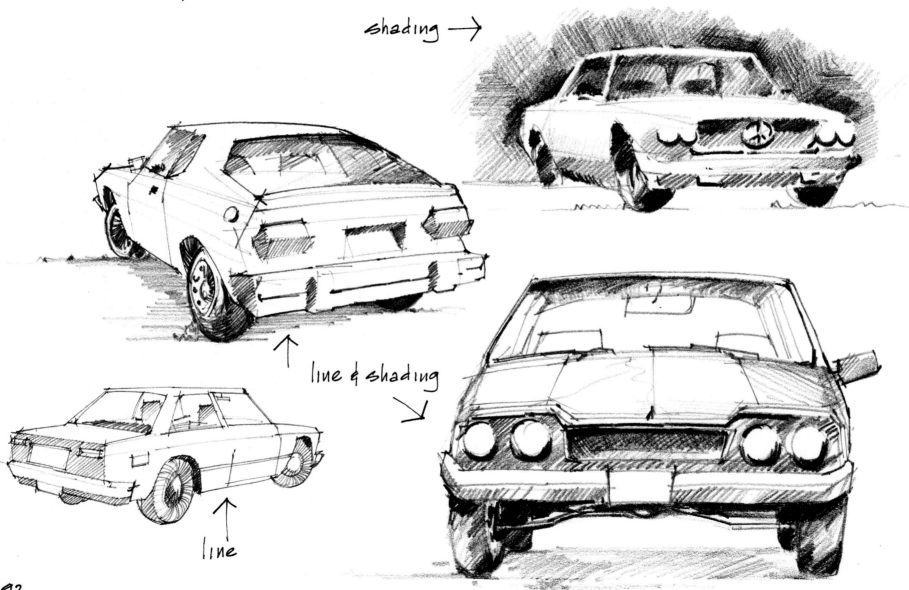

line & shading

line

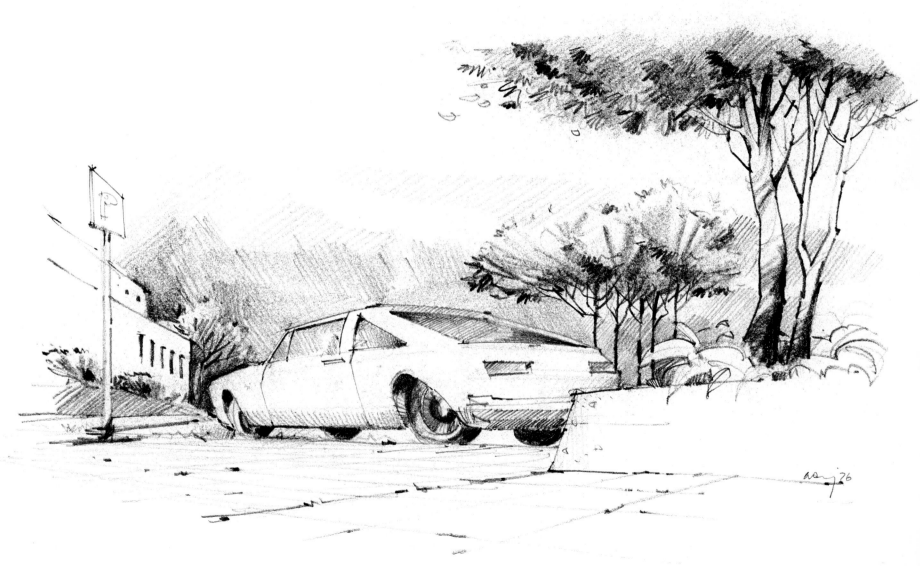

REFERENCE BOOKS

Black, Arthur . LANDSCAPE SKETCHING.
New York, McGraw-Hill. 1950

Guptill. Arthur. PENCIL DRAWING. New York,
Reinhold Publishing Corp., 1959

Kautzky. Ted. PENCIL BROADSIDES
New York, Van Nostrand Reinhold,
1960

Kautzky. Ted . PENCIL PICTURES. New York,
Reinhold Publishing Corp., 1947

Watson. Ernest. PENCIL SKETCHING - Book 1,
New York, Reinhold Publishing
Corp., 1956

Watson, Ernest. THE ART OF PENCIL DRAWING.
New York, Watson-Guptill Co.,
1968

INDEX